WICKED

OFFICIAL COLORING BOOK

WICKED

OFFICIAL COLORING BOOK

Illustrated by Carolina Zambrano

DEYST.

An Imprint of William Morrow

DEYST.

HarperCollins books may be purchased for educational, business, or sales promotional use. For information, please email the Special Markets Department at SPsales@harpercollins.com.

FIRST EDITION

Illustrations by Carolina Zambrano
Design by Alison Bloomer

Library of Congress Cataloging-in-Publication Data has been applied for.

ISBN 978-0-06-341382-5

24 25 26 27 28 LBC 5 4 3 2 1

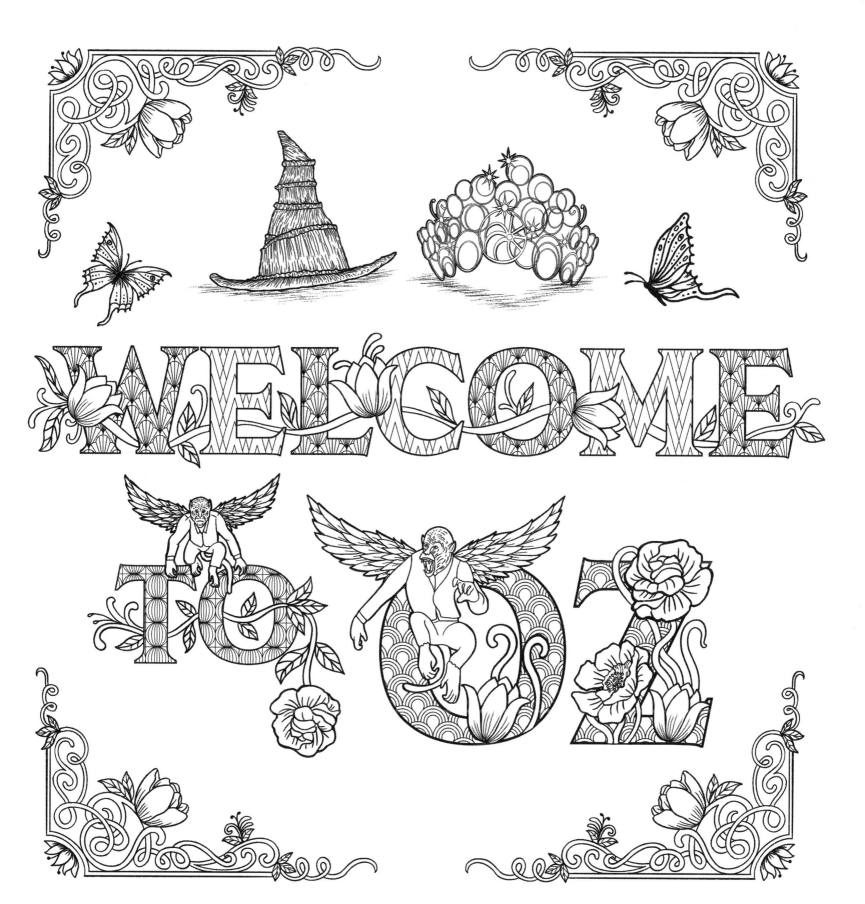

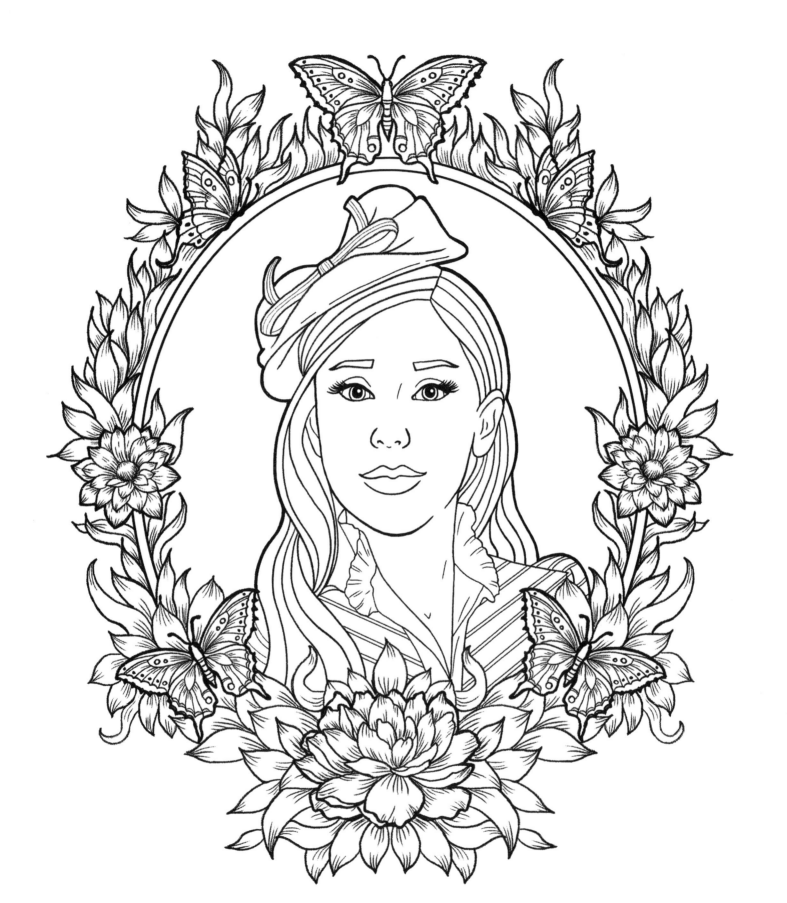

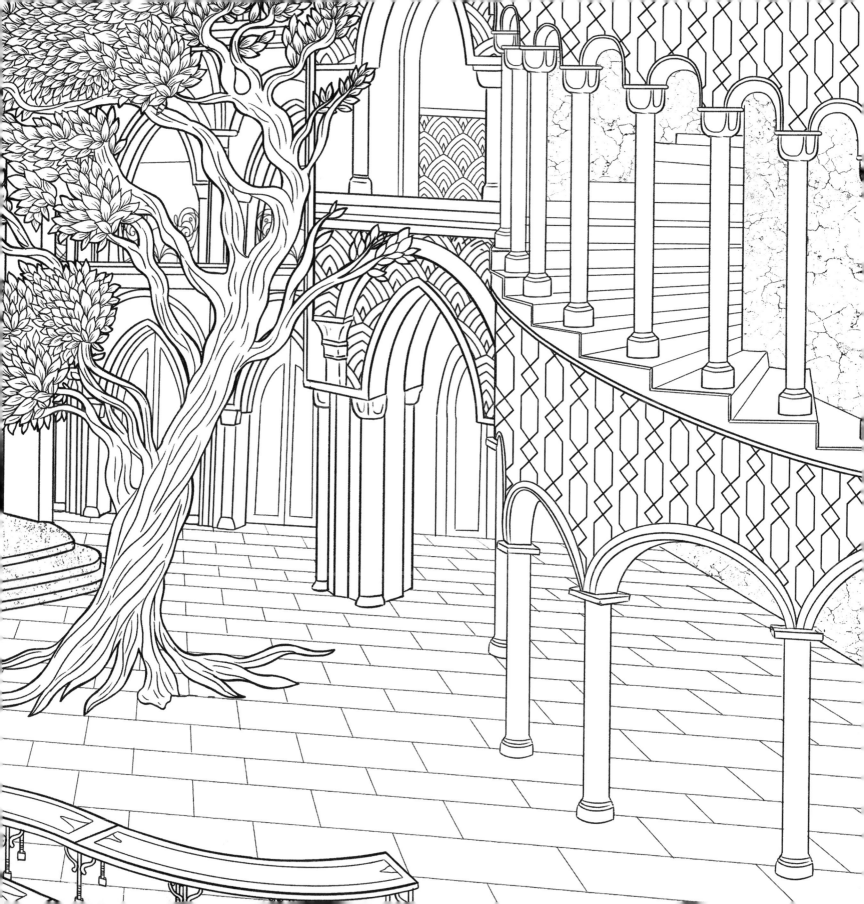

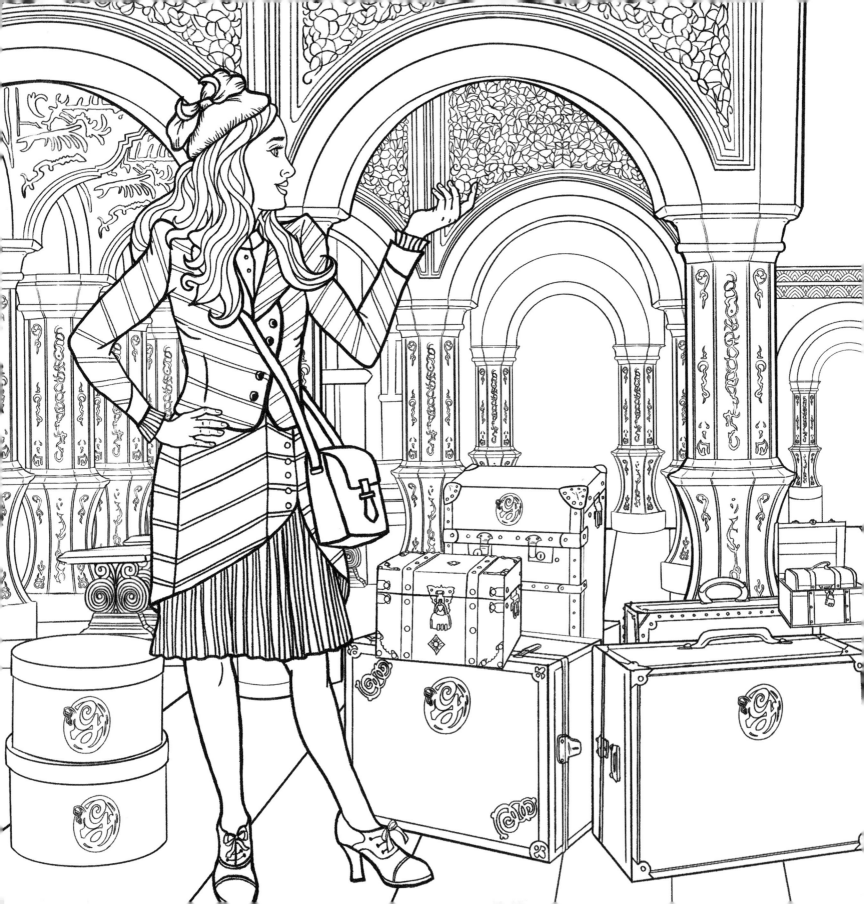

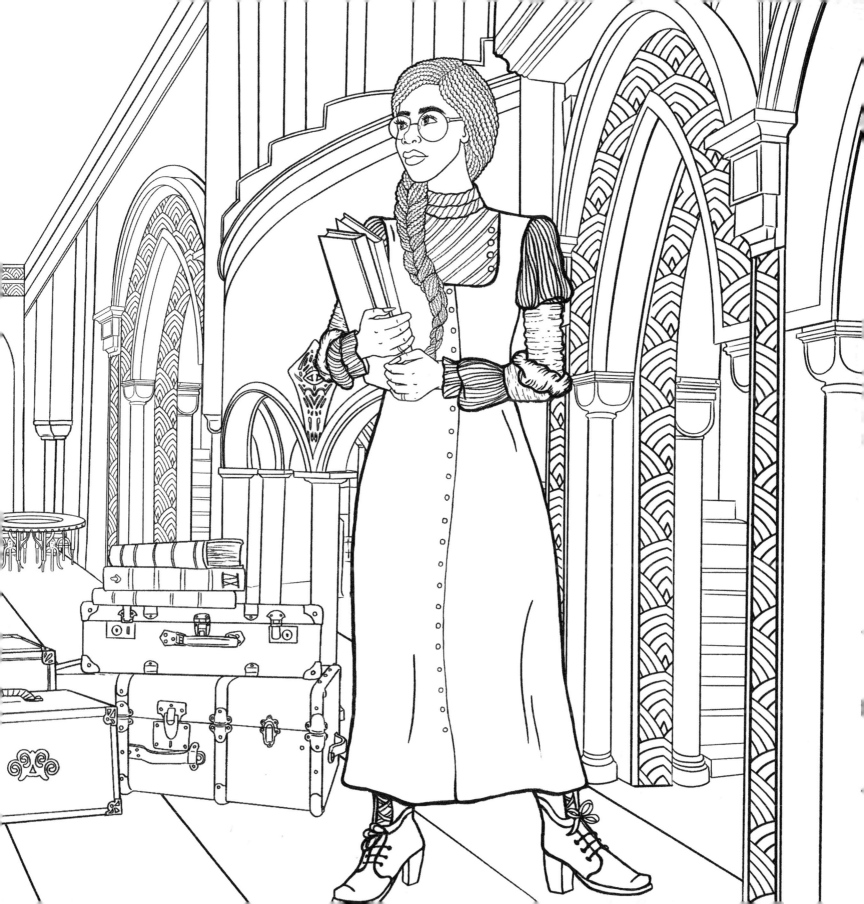

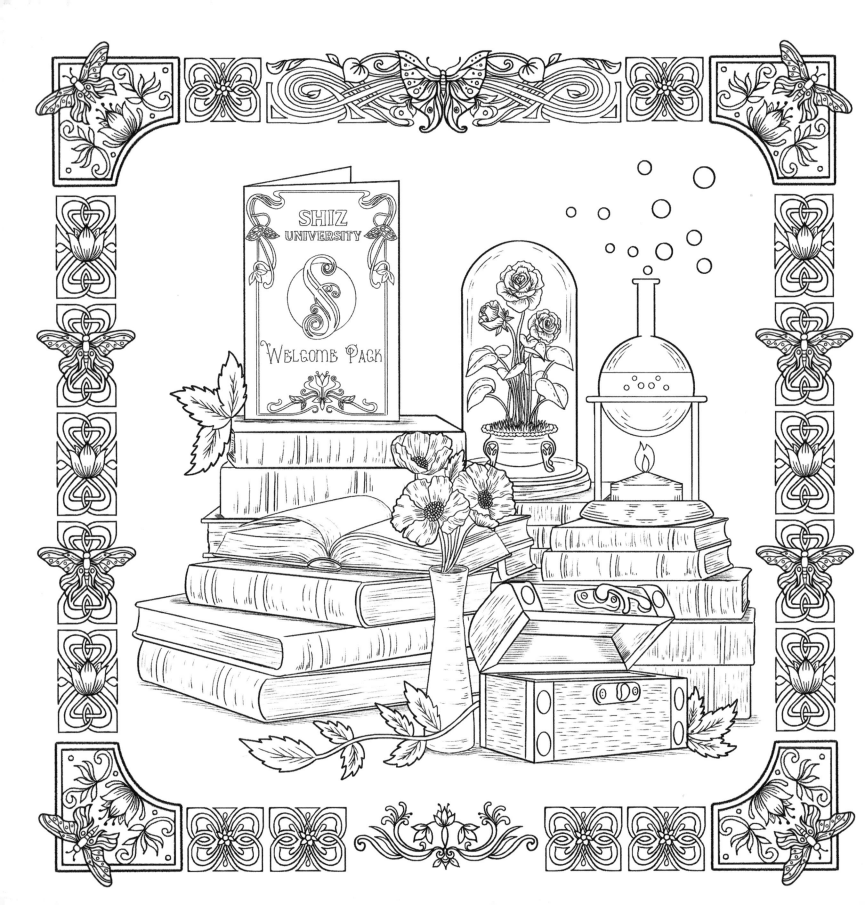

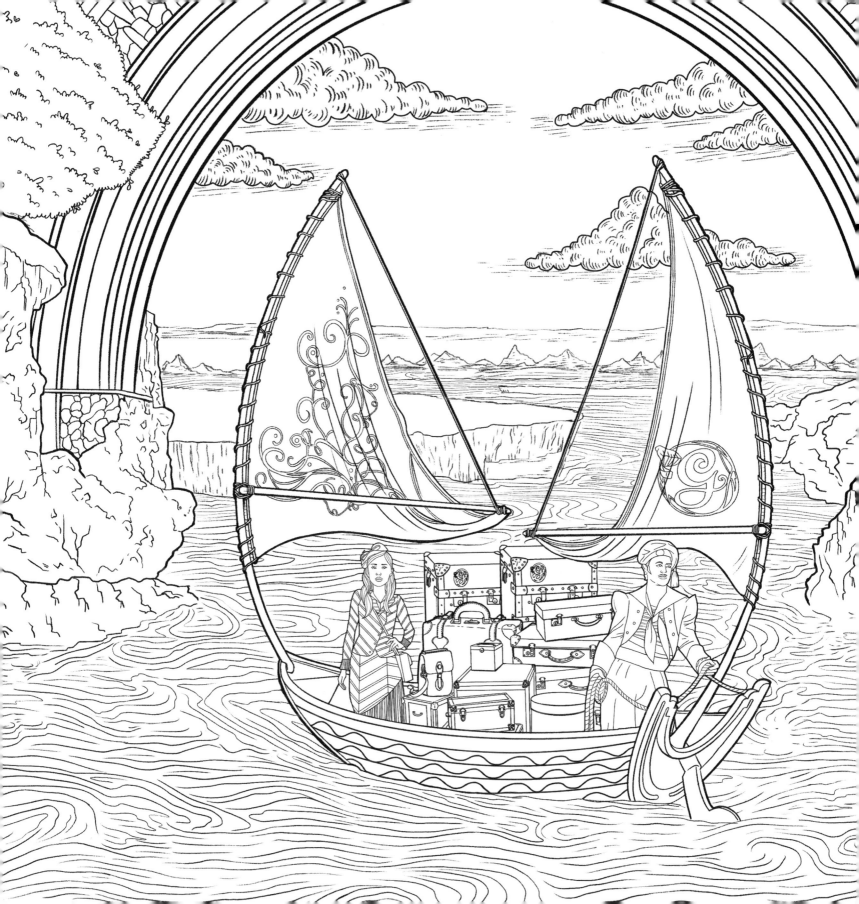

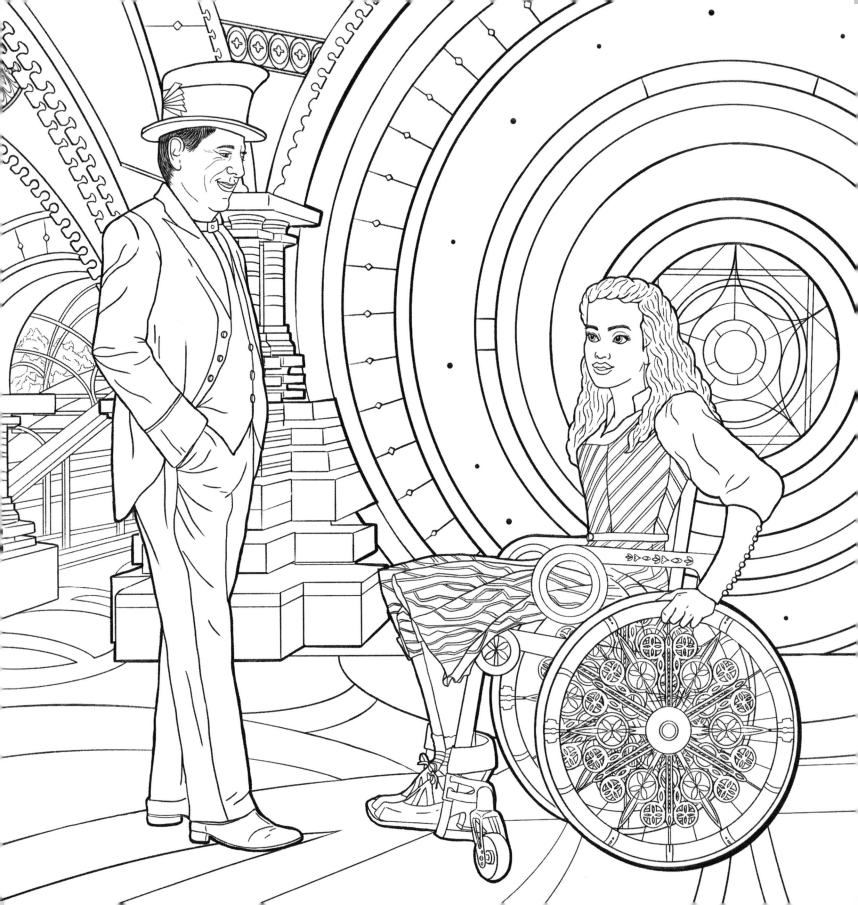

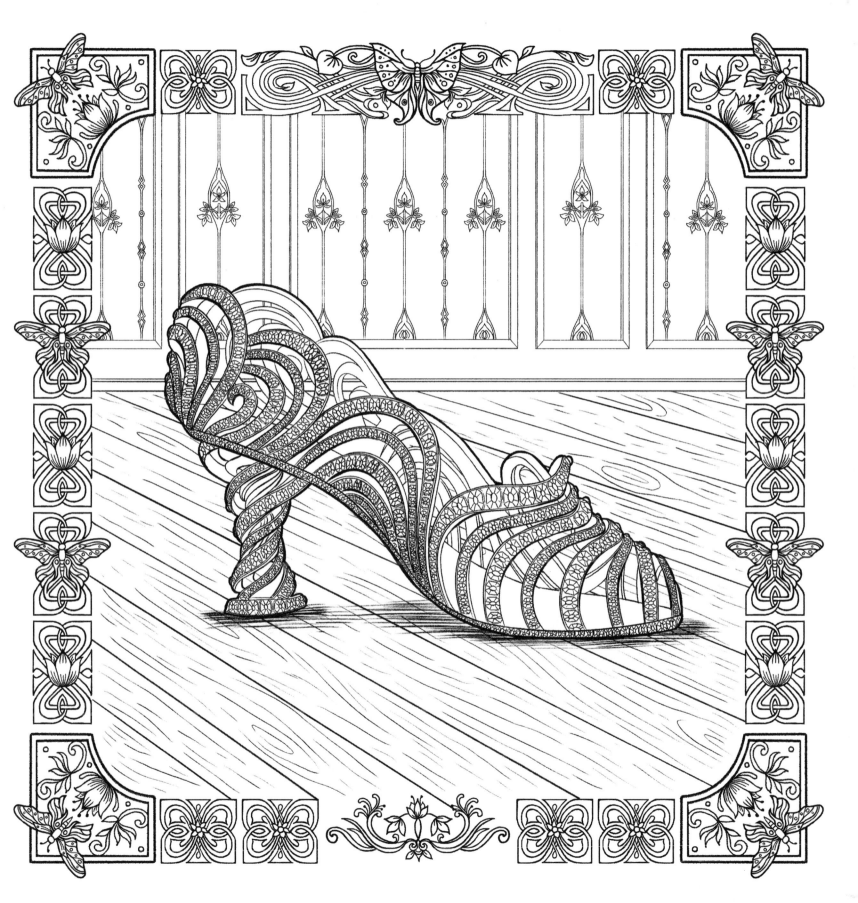

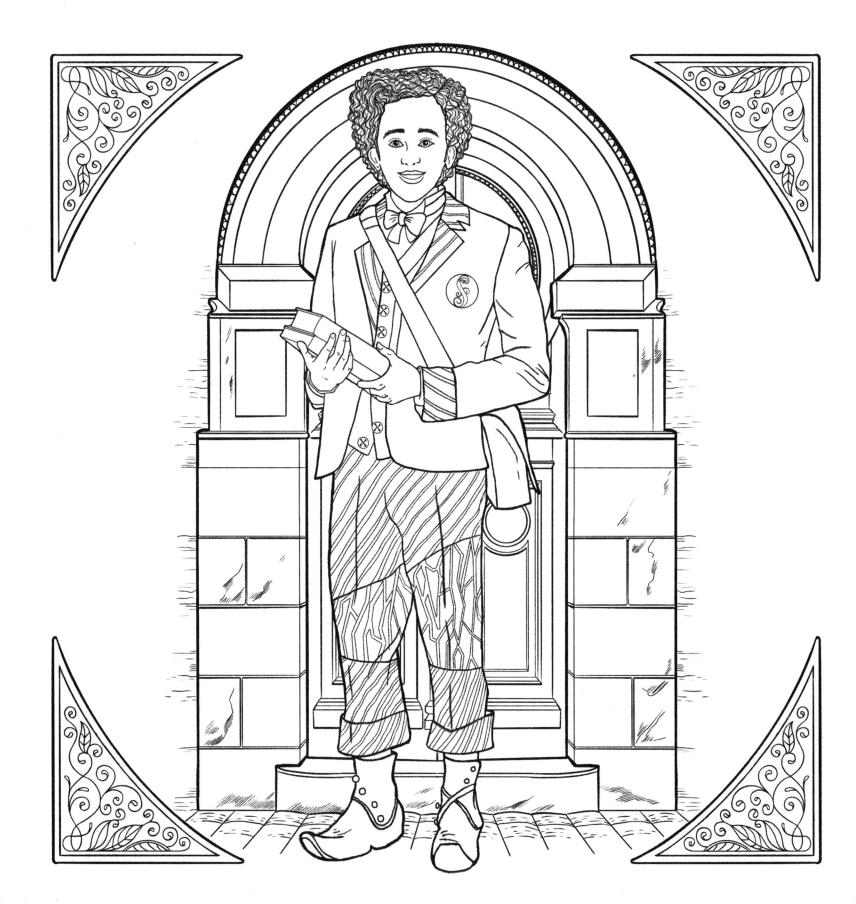

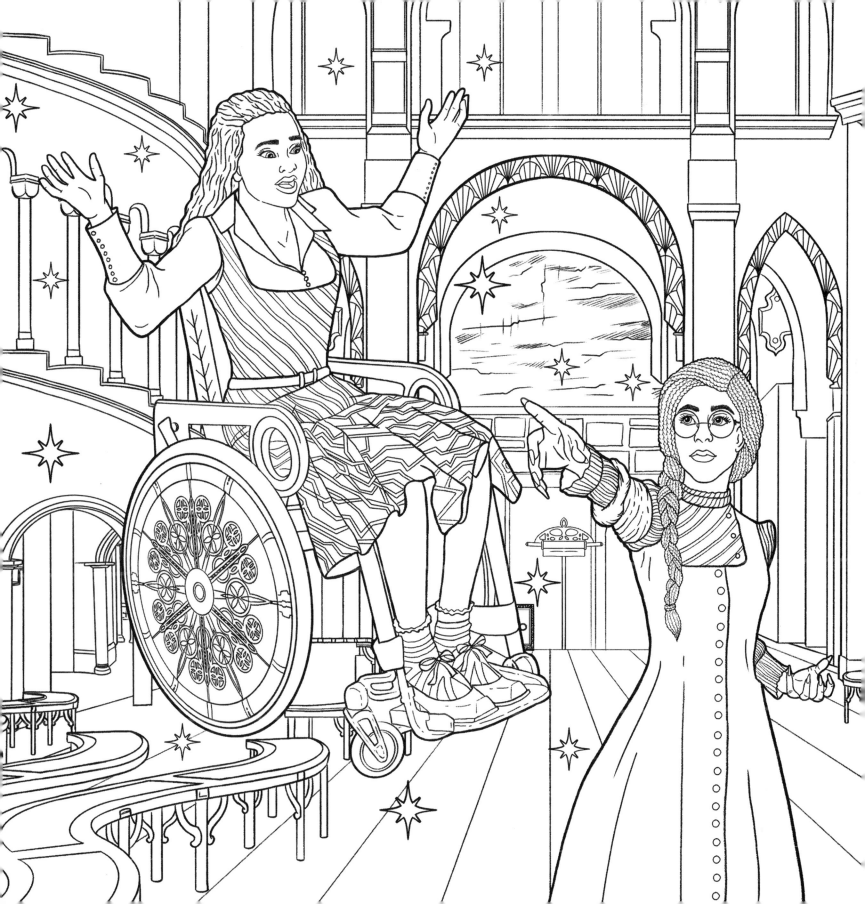

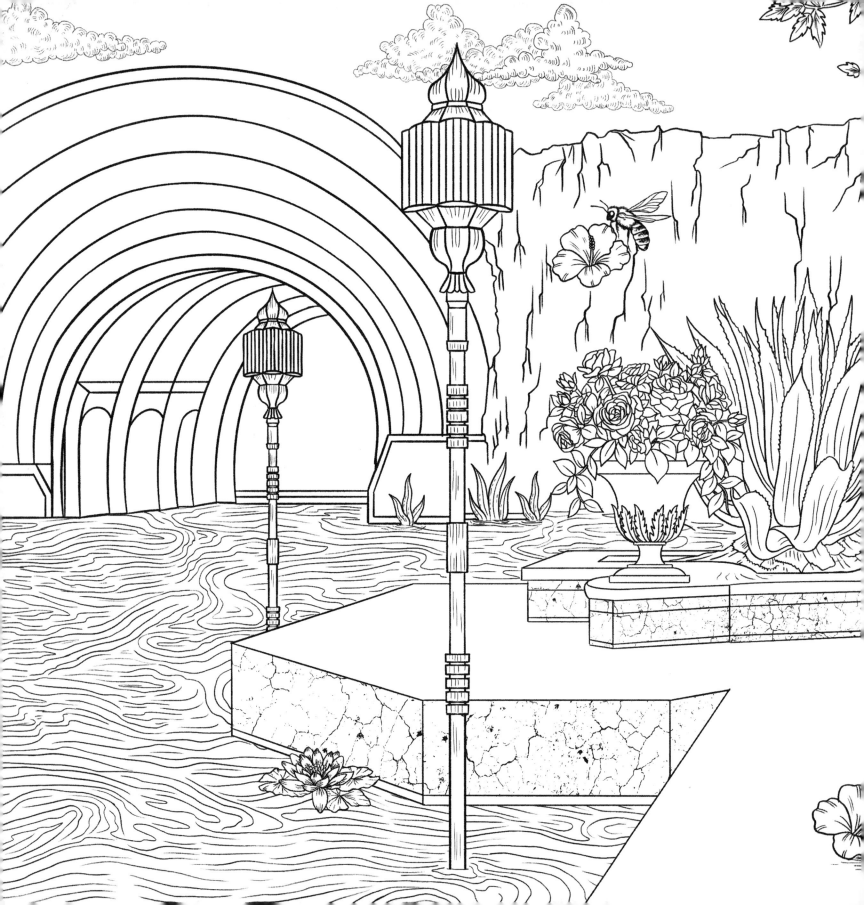

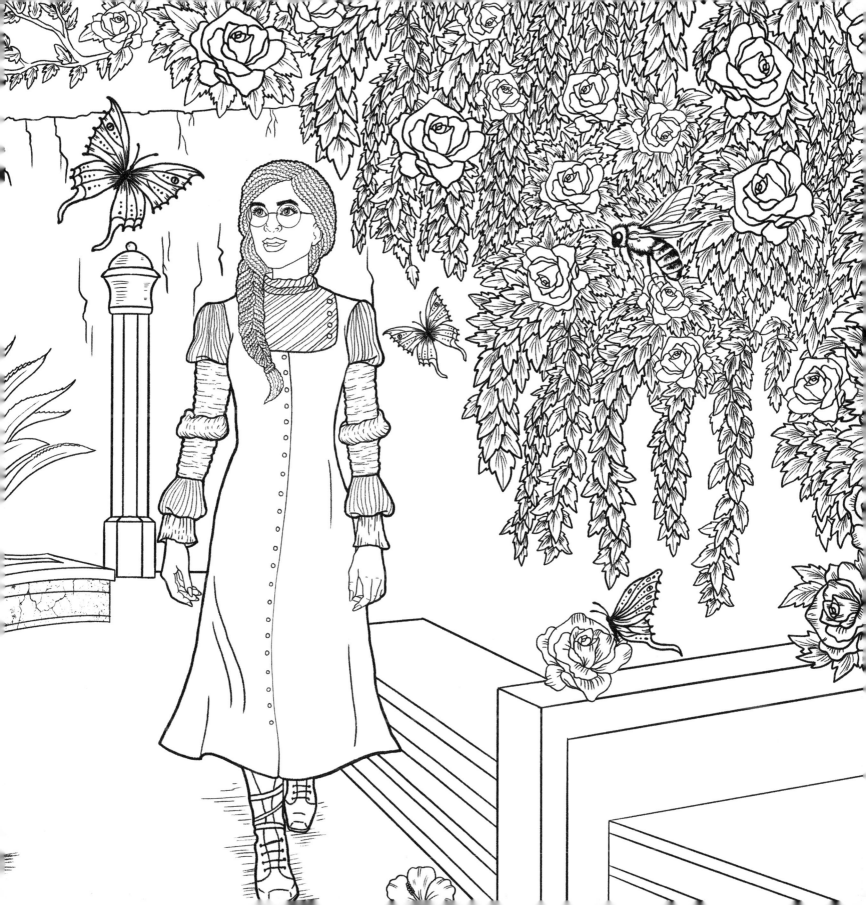

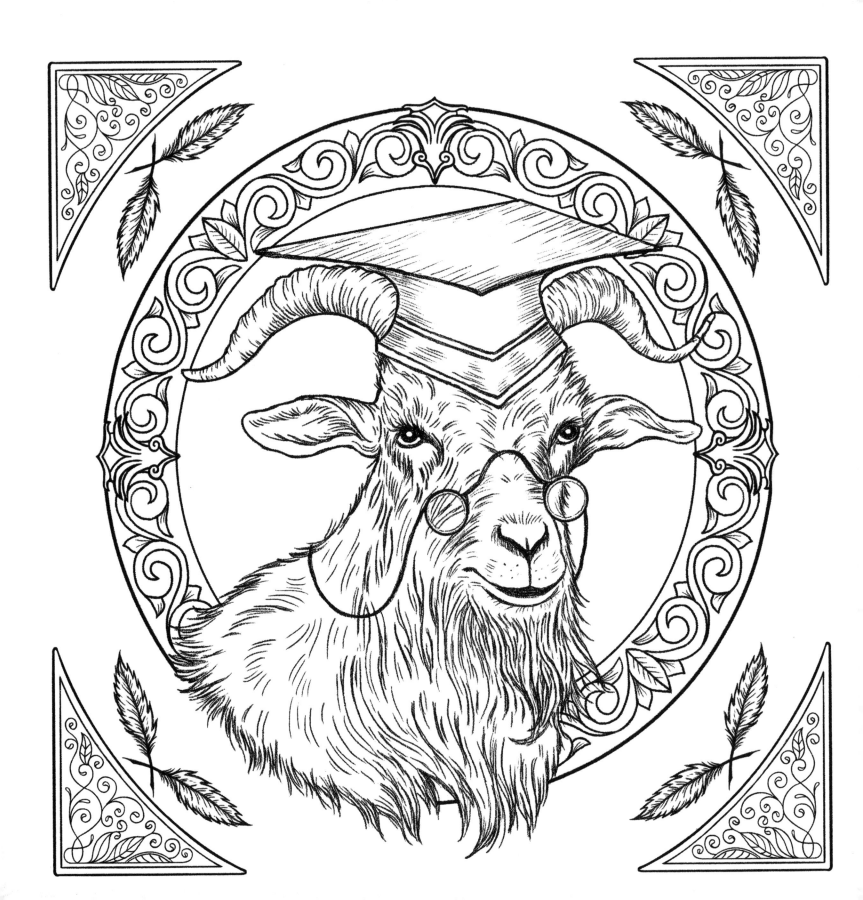

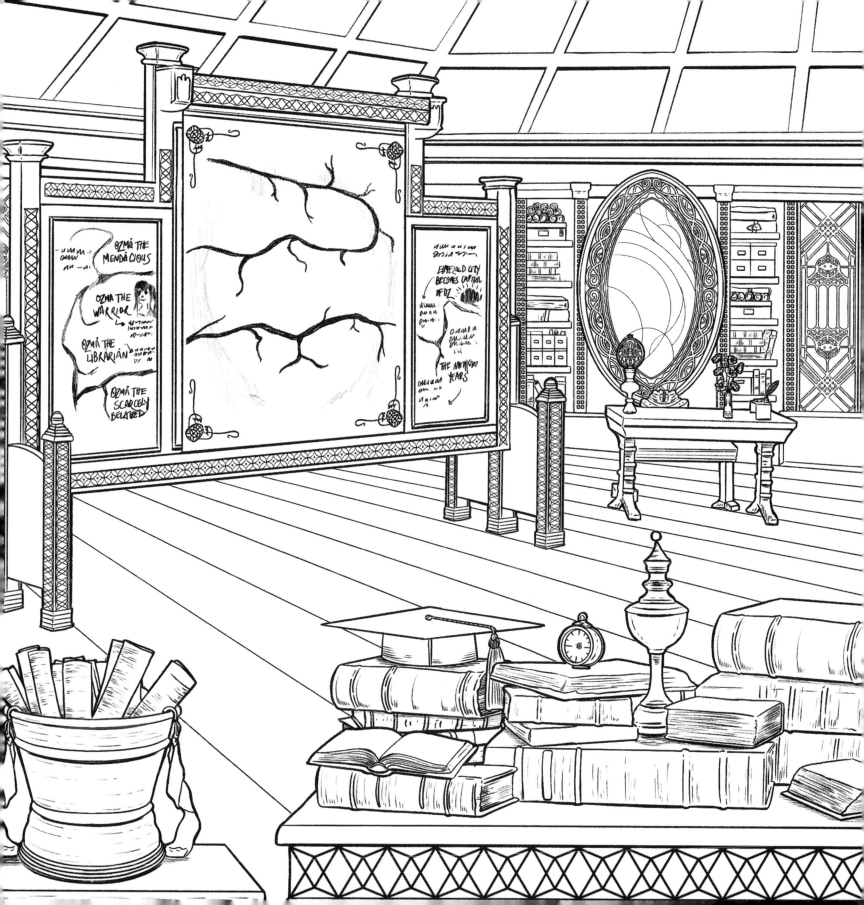

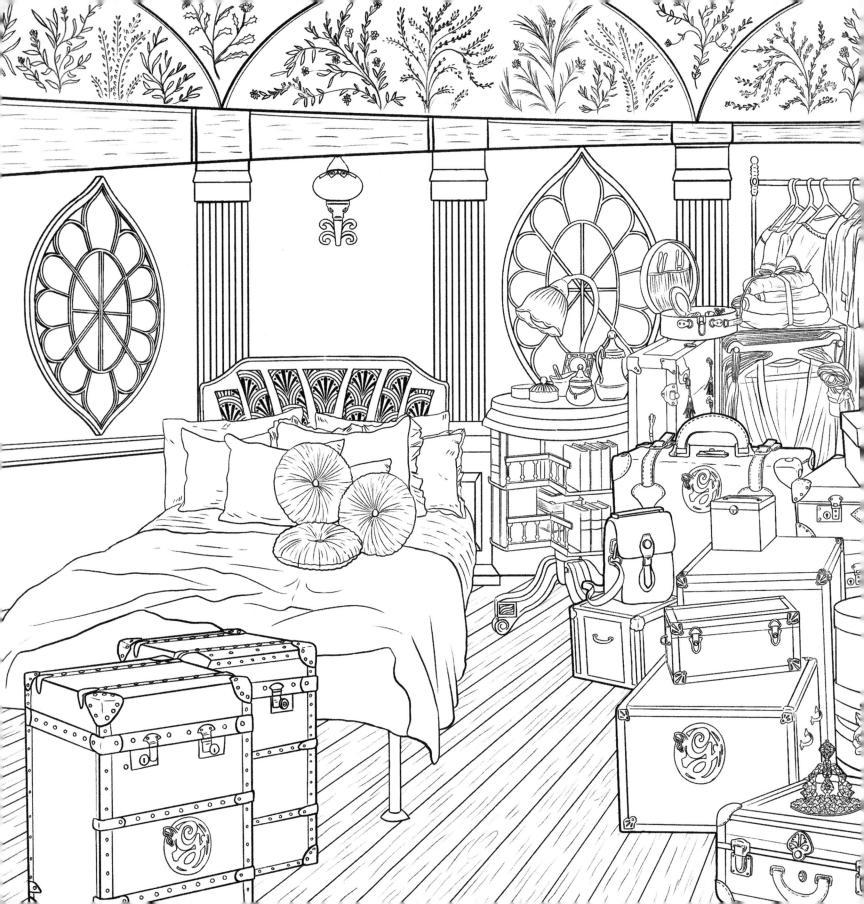

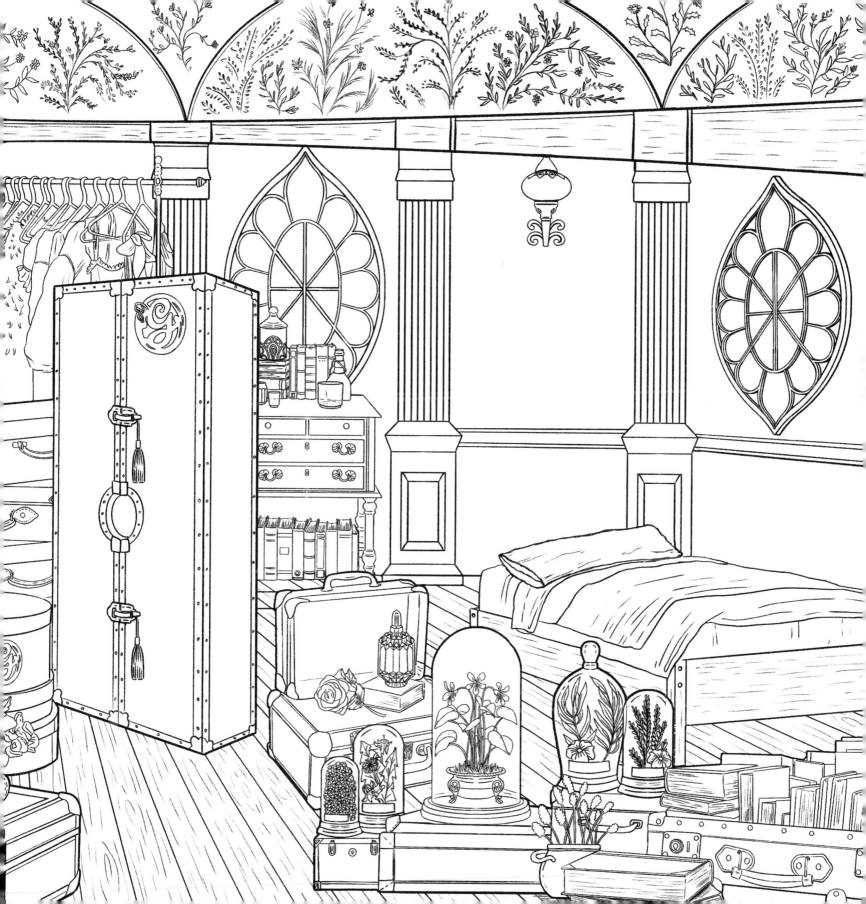

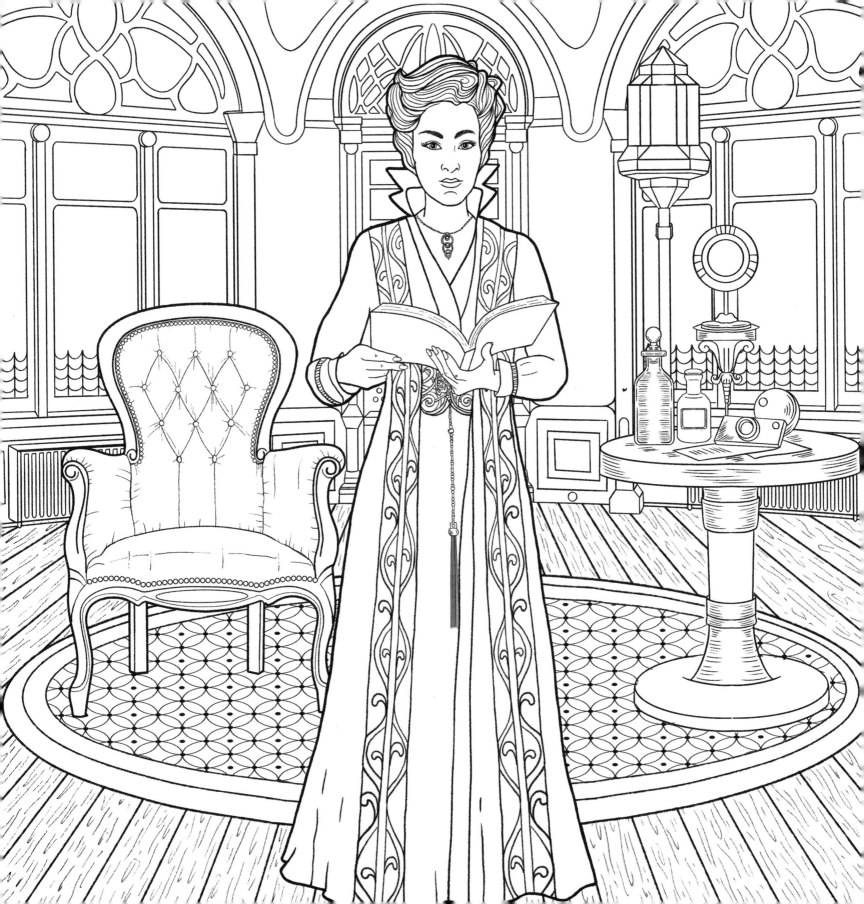

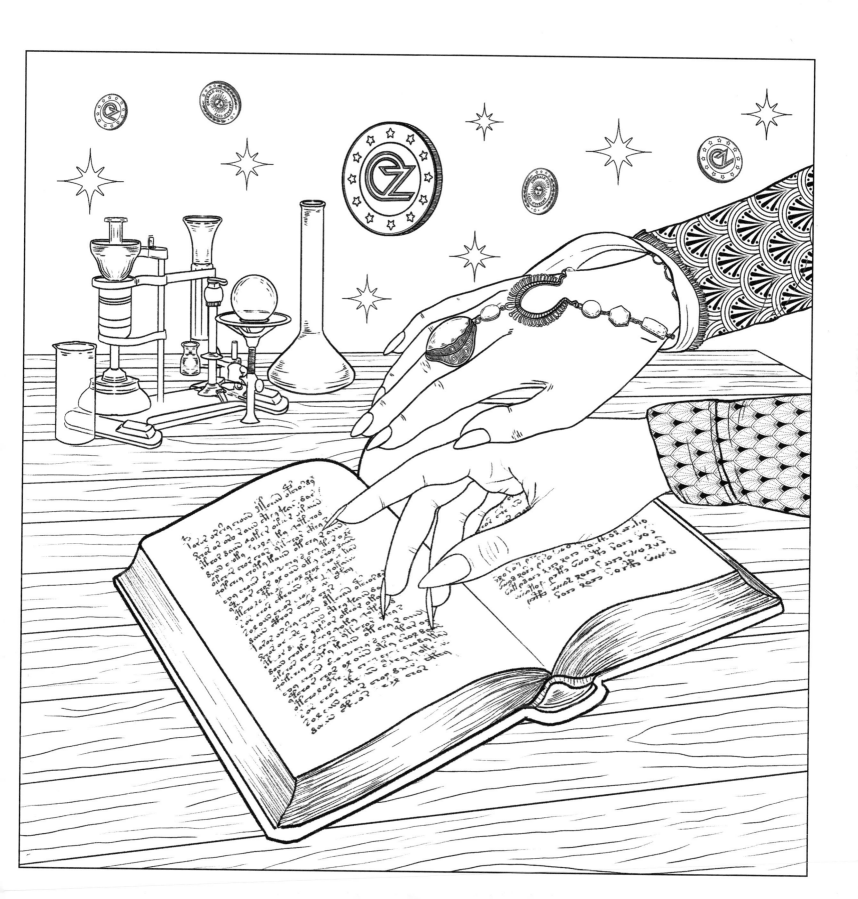

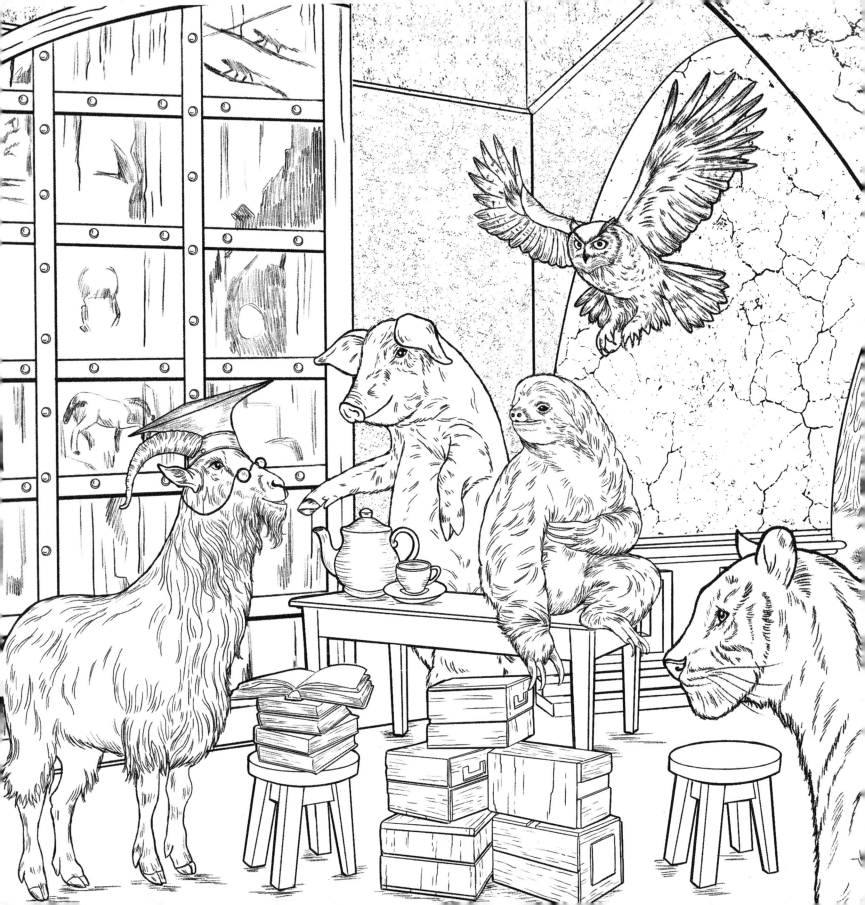

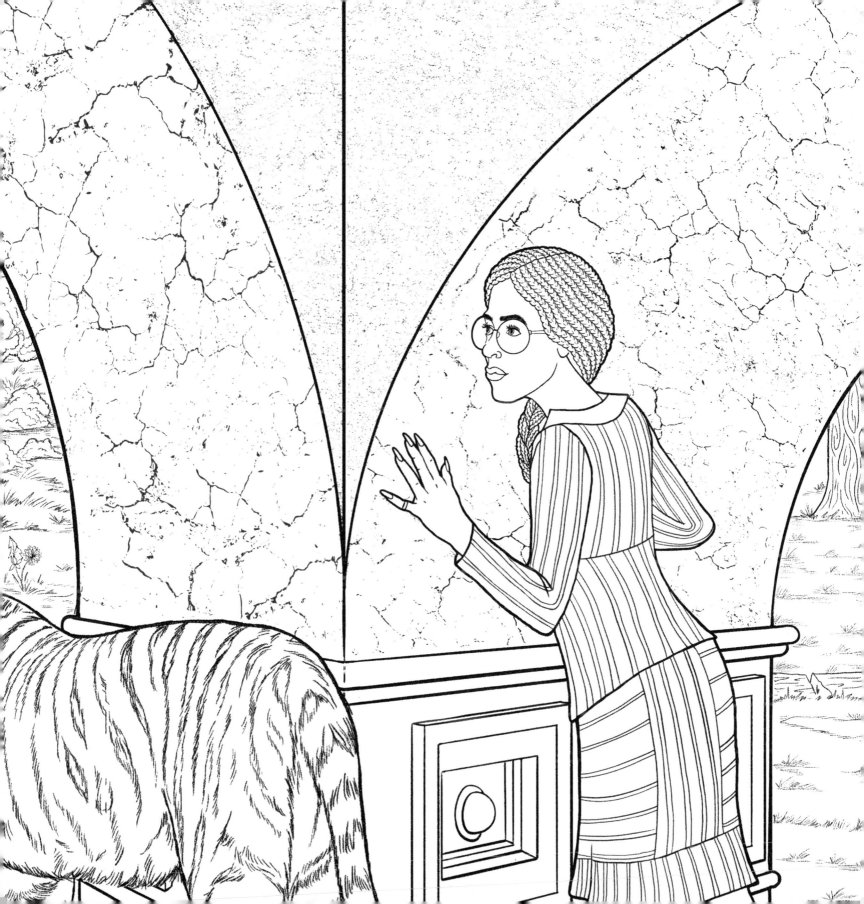

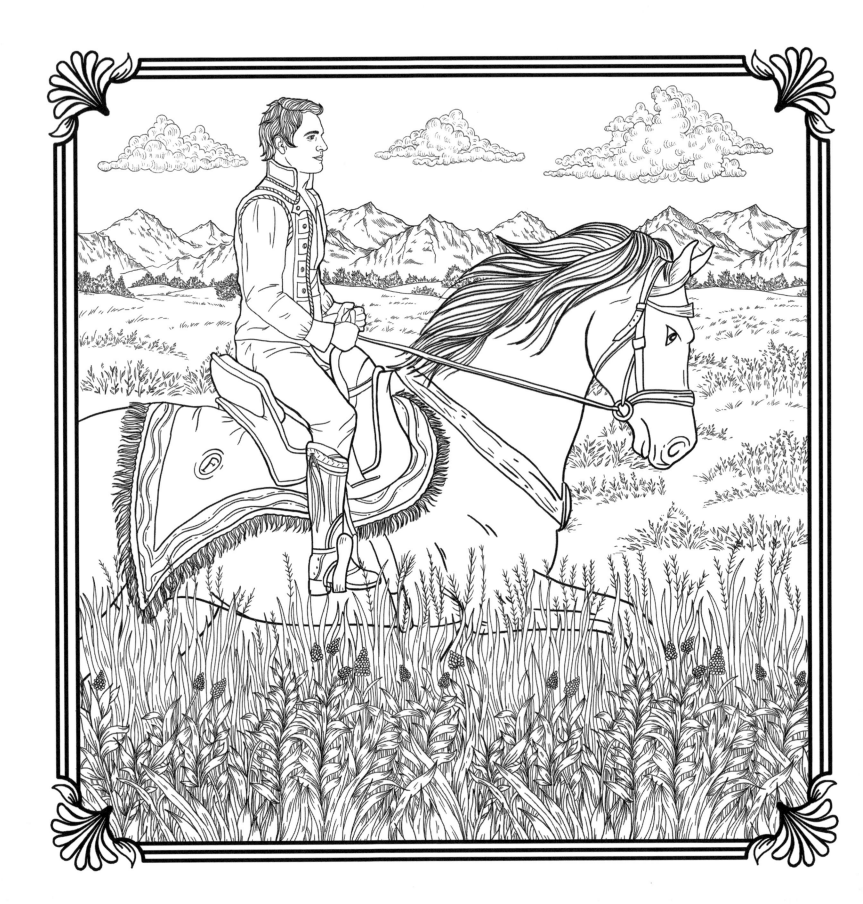

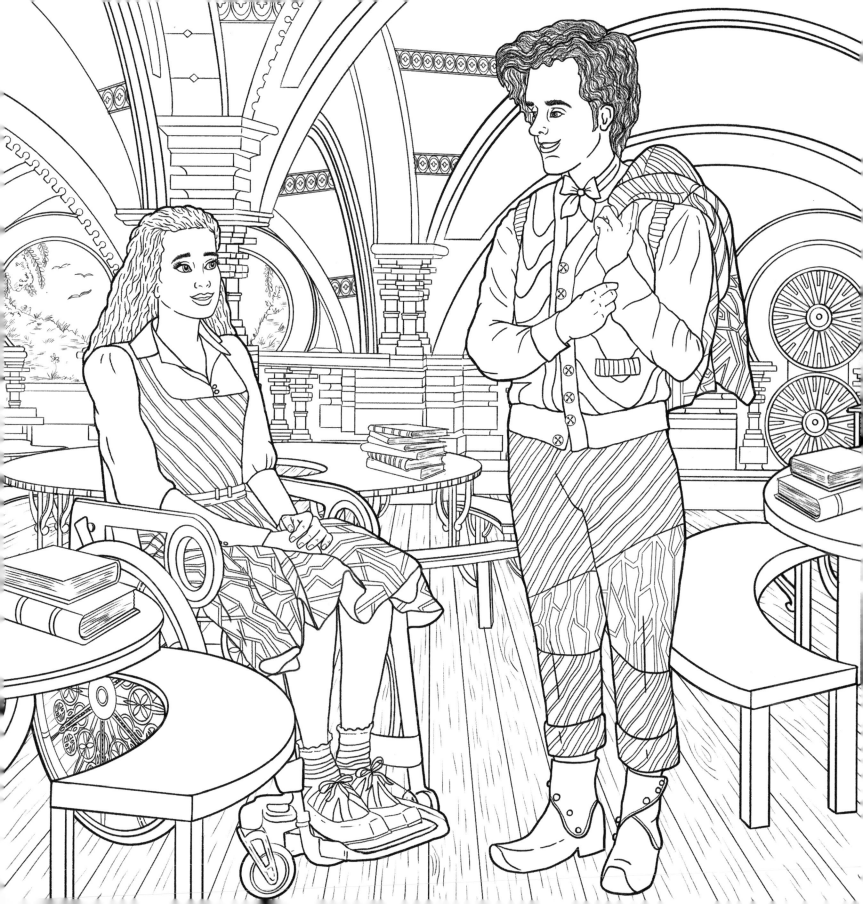

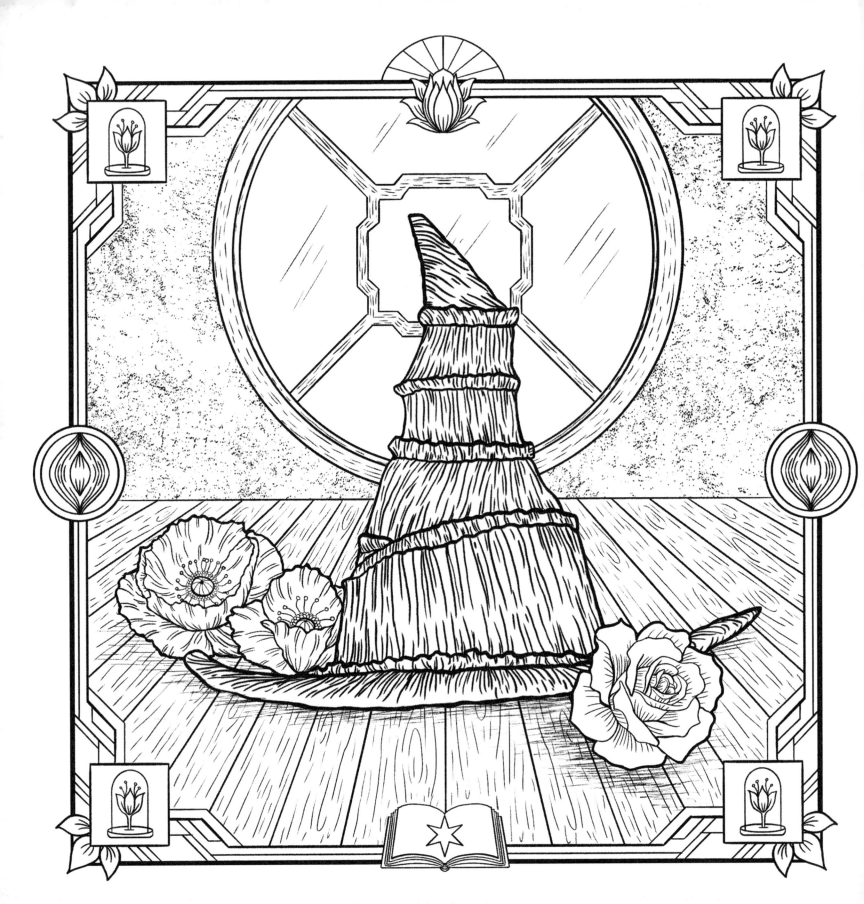

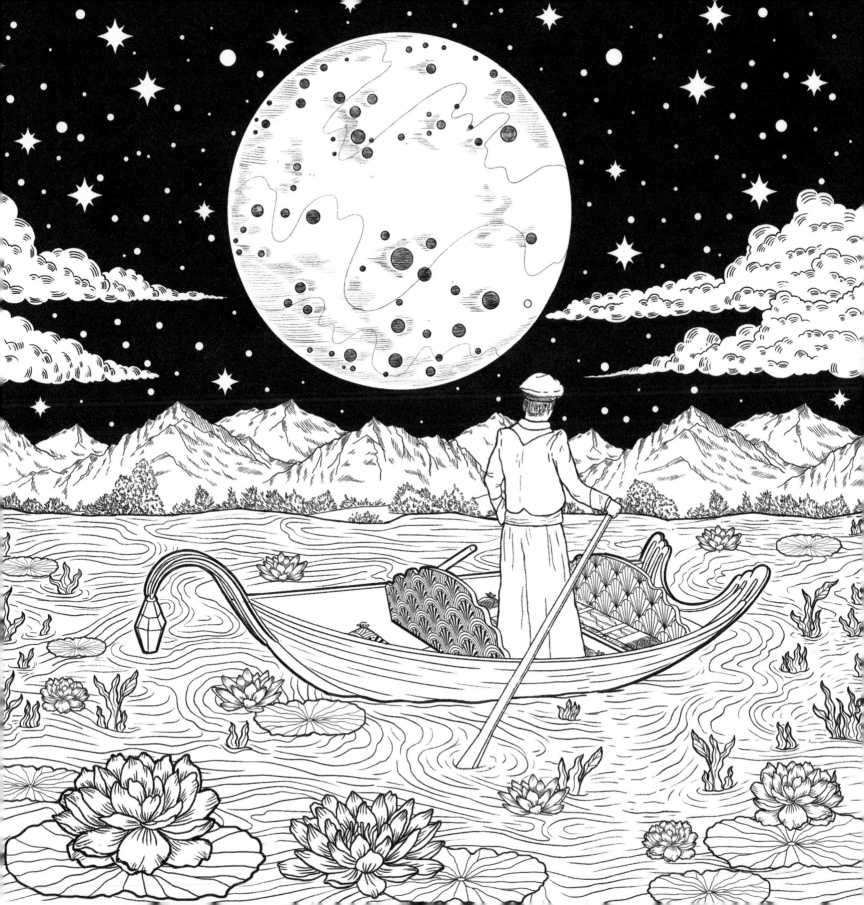

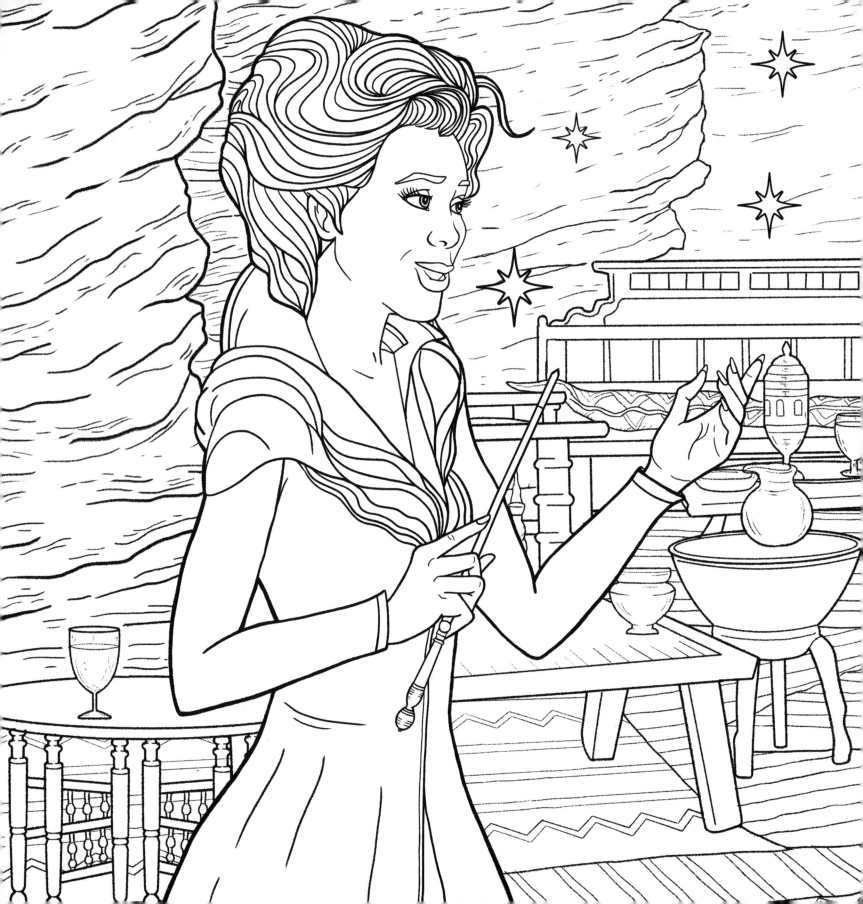

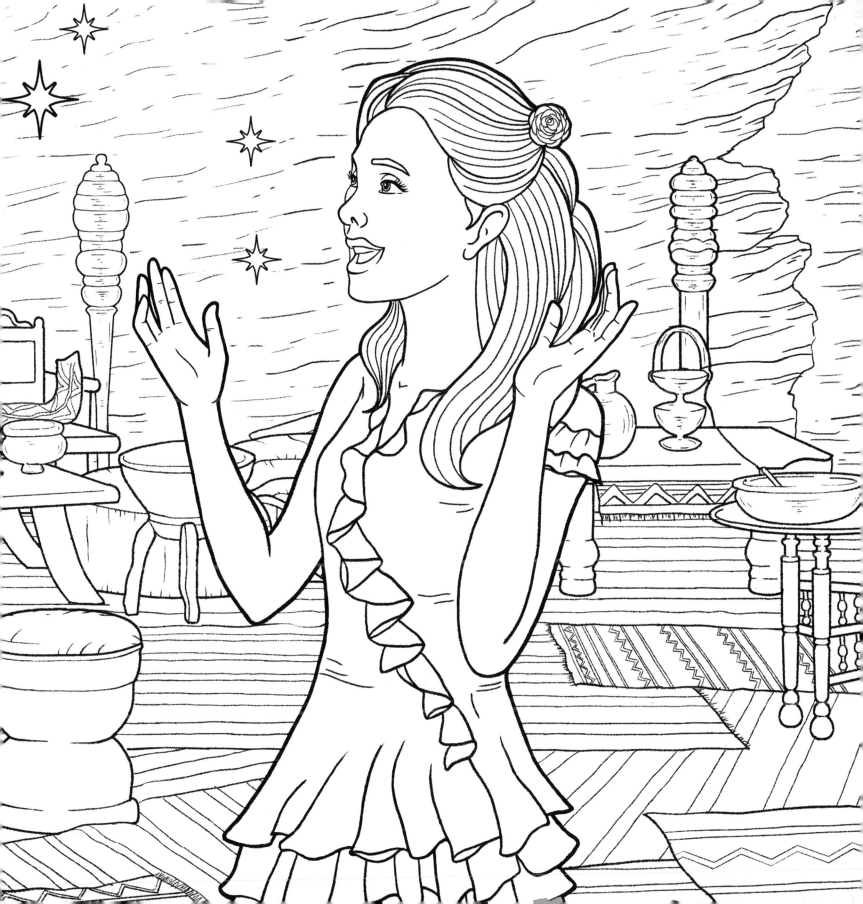

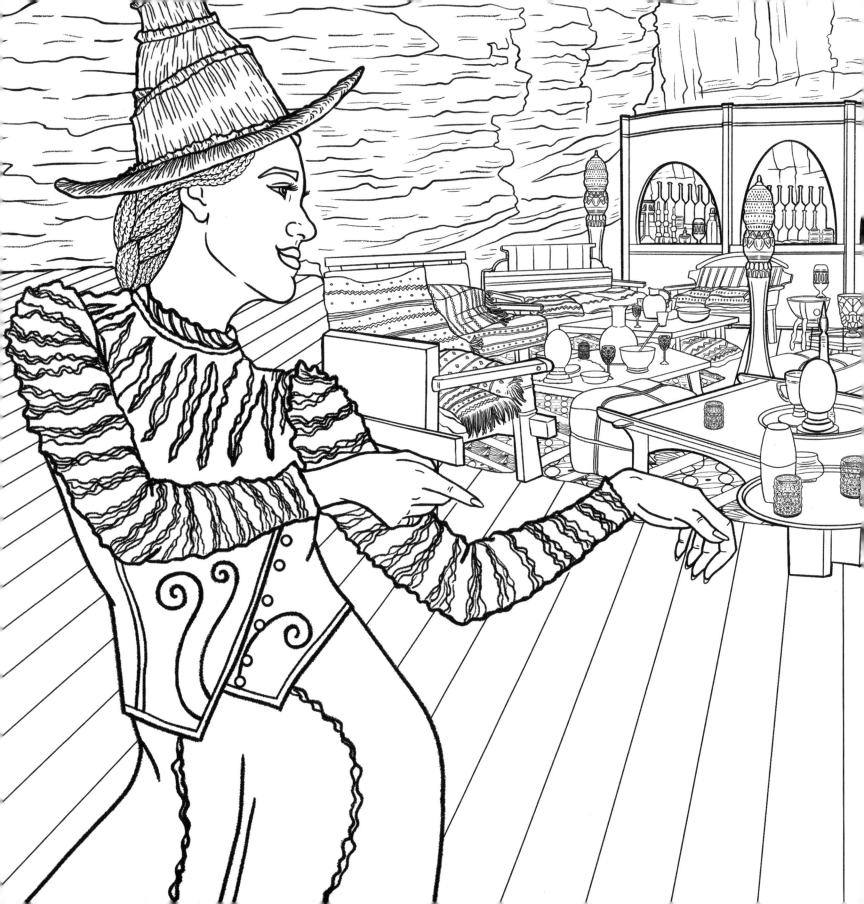

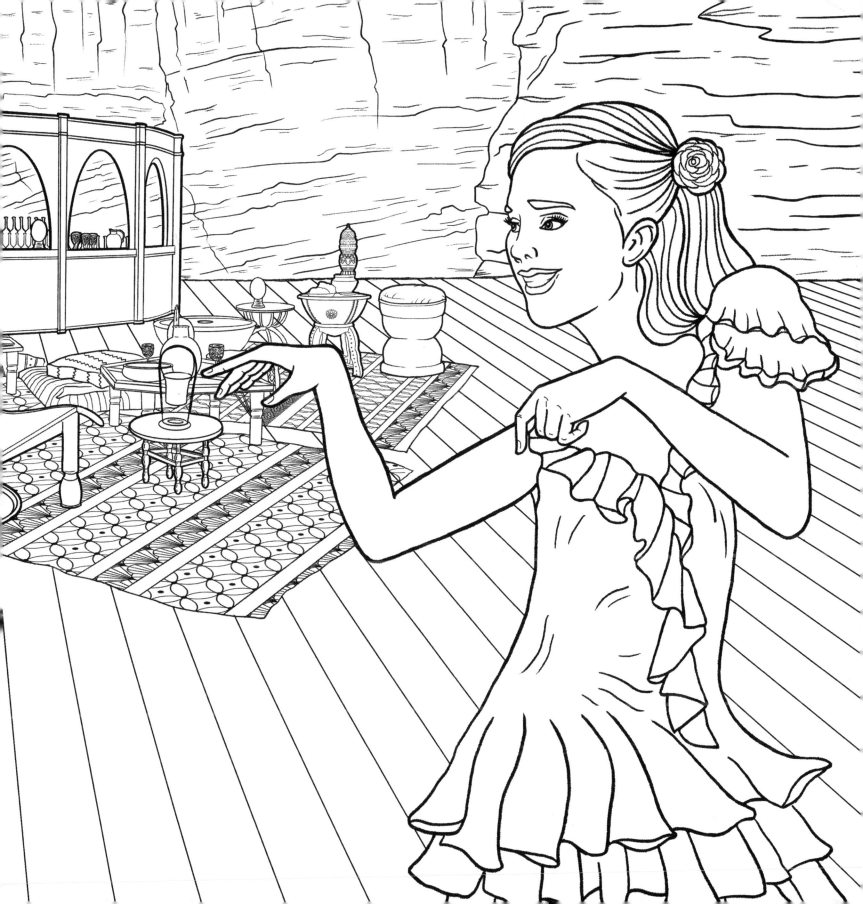

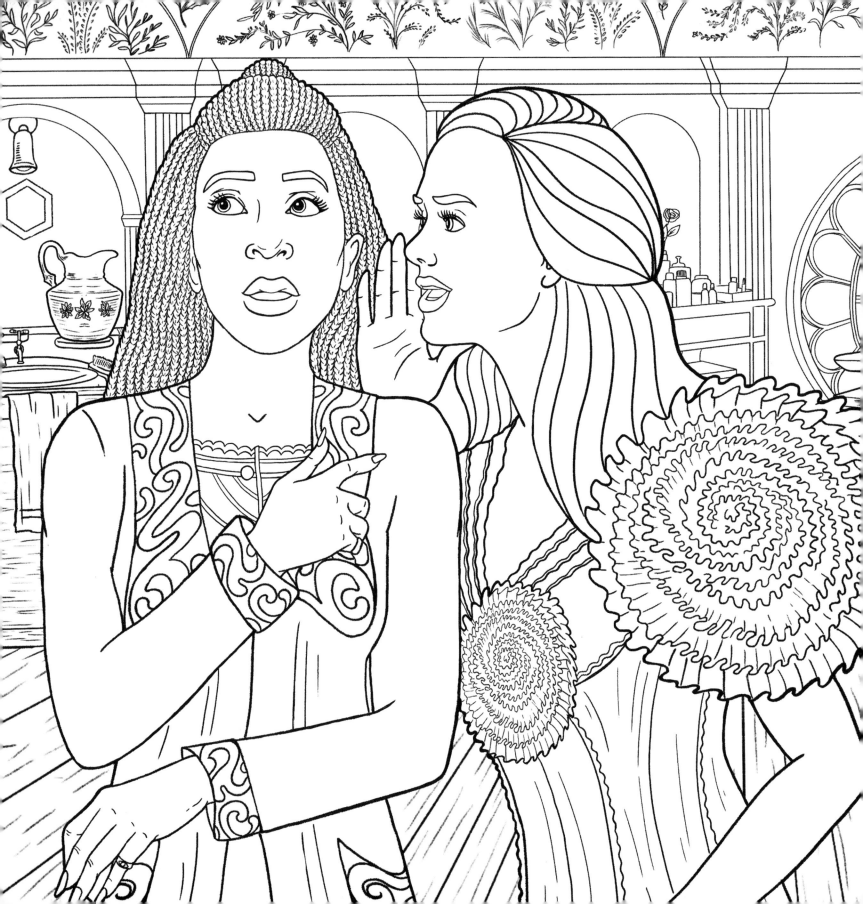

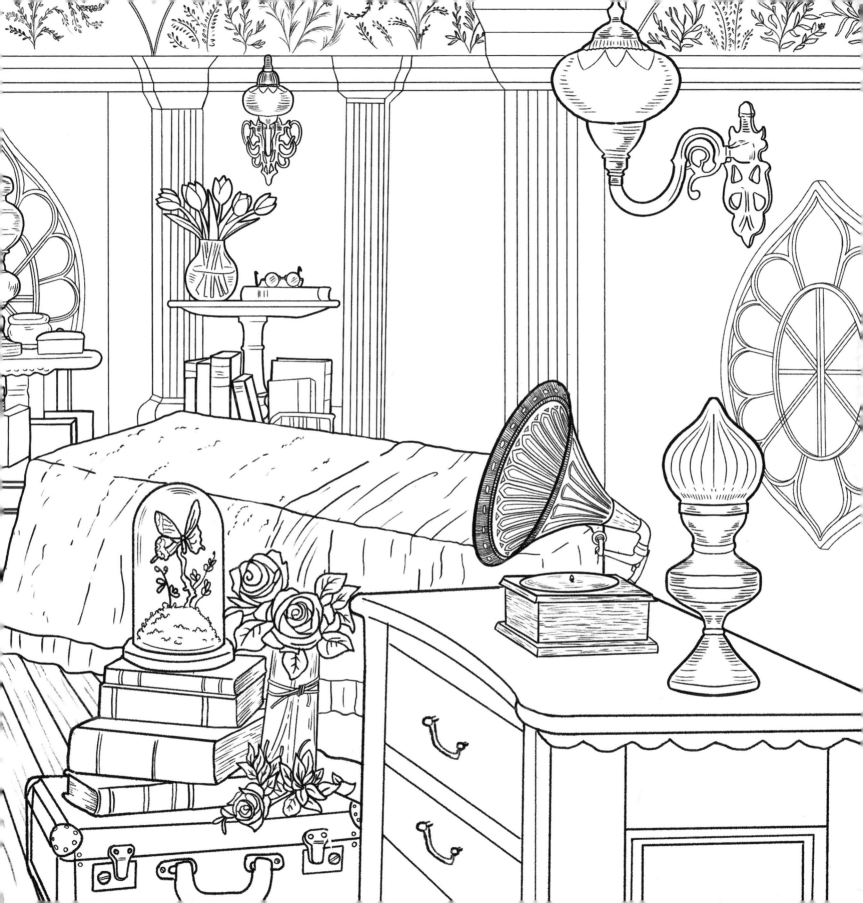

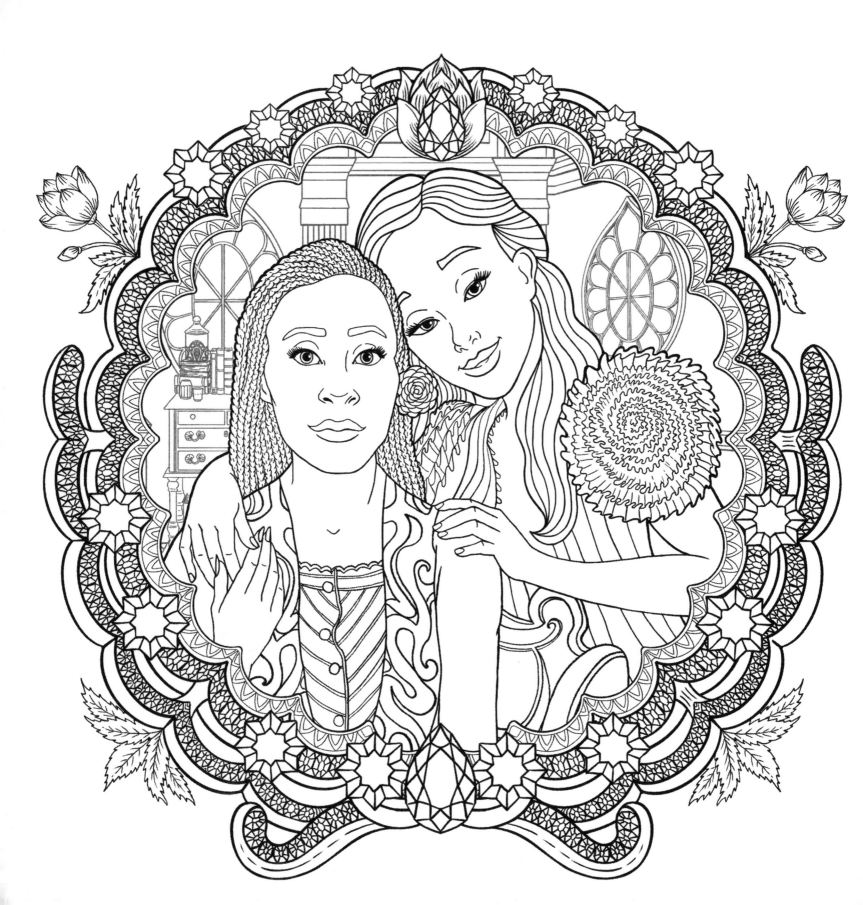

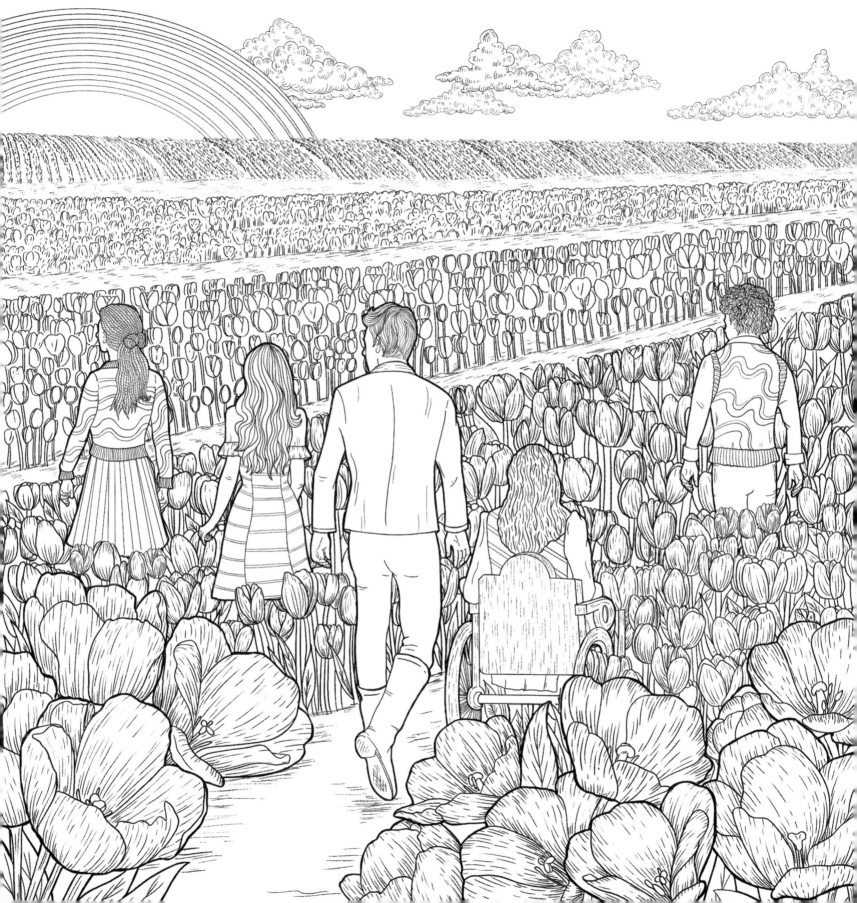

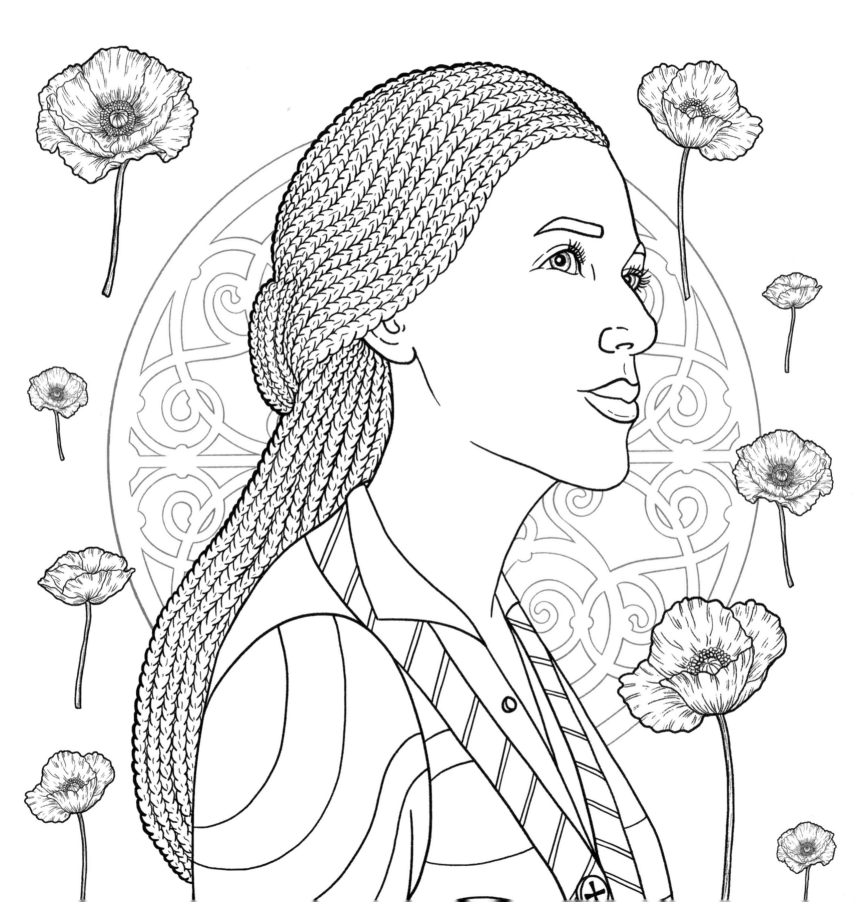

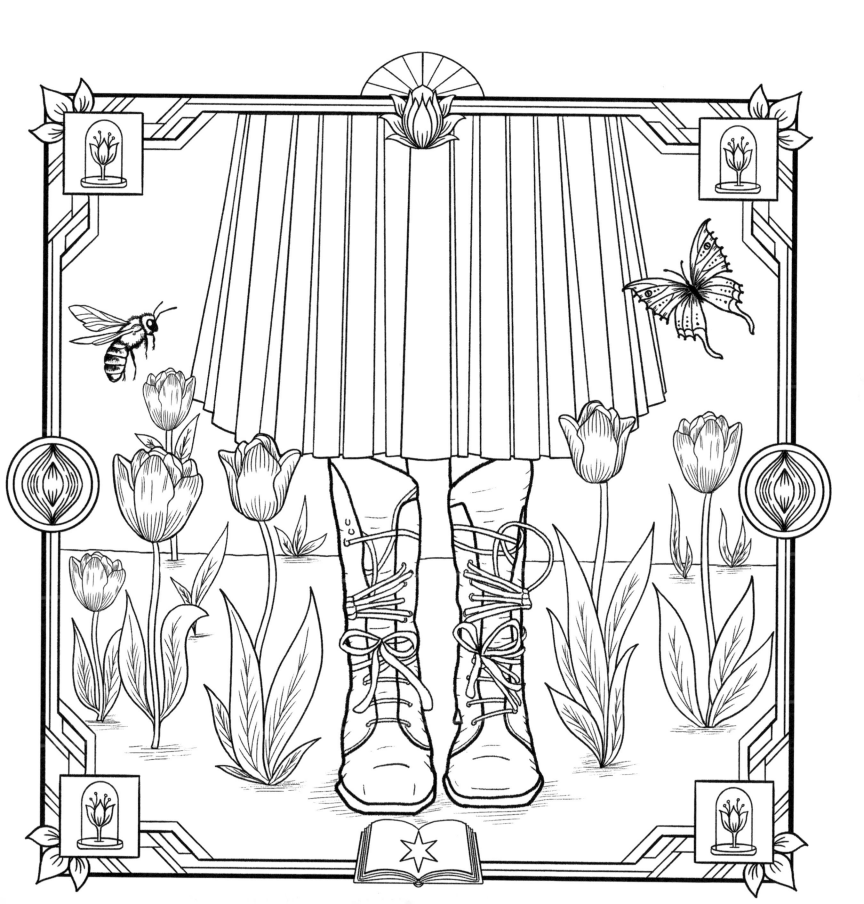

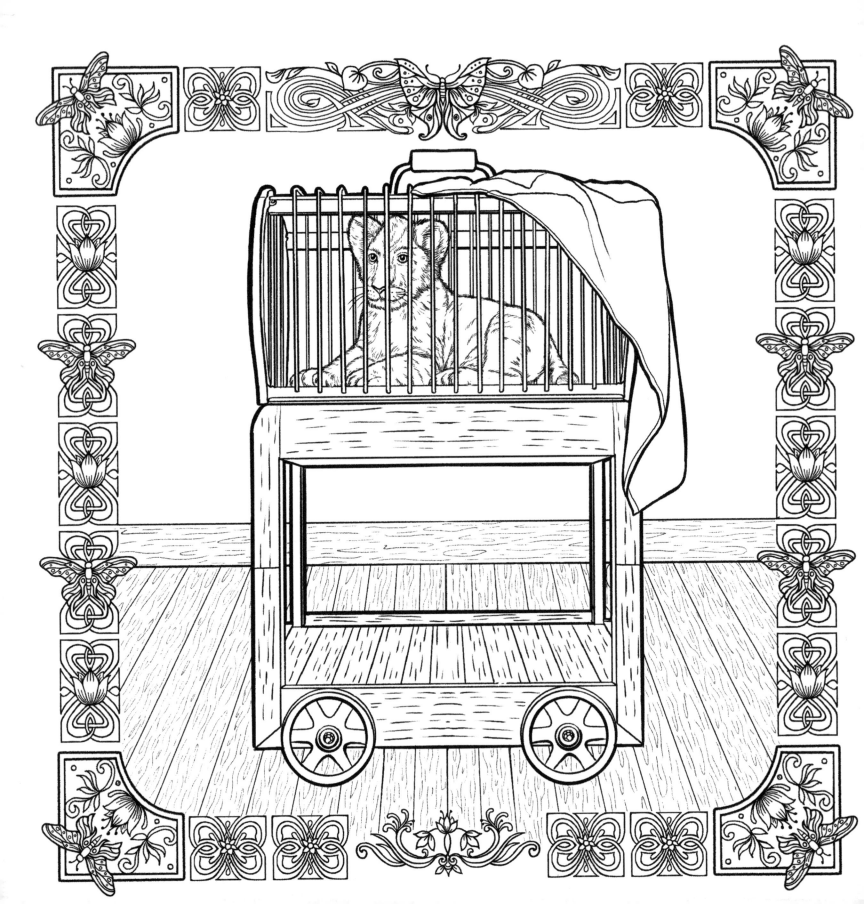

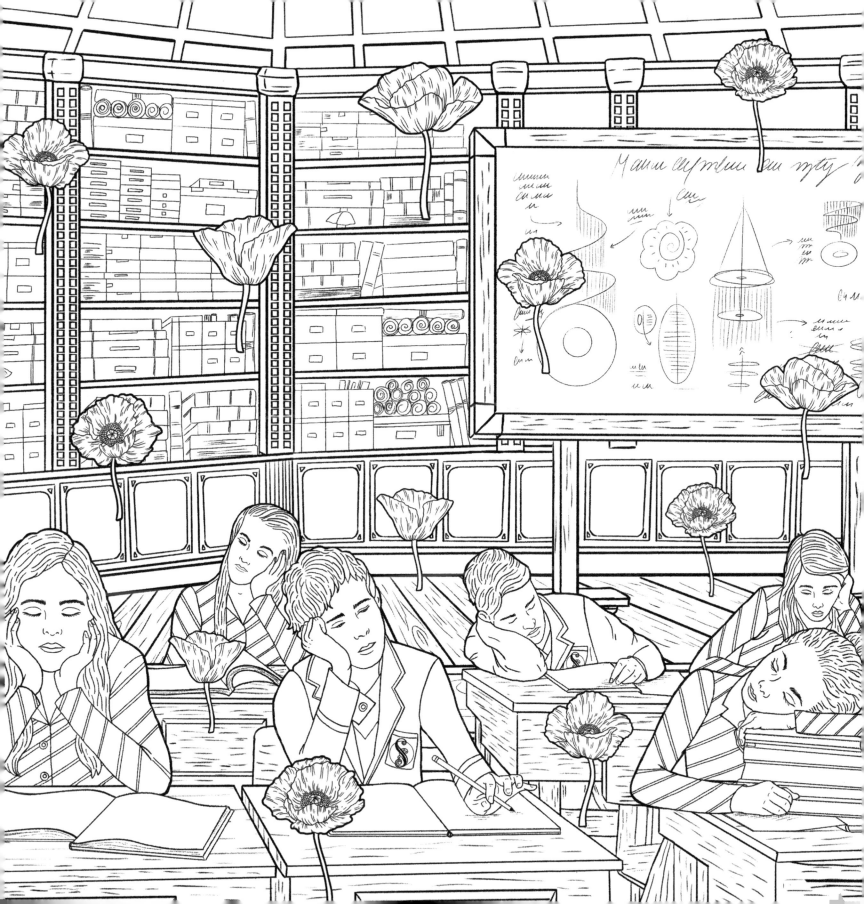

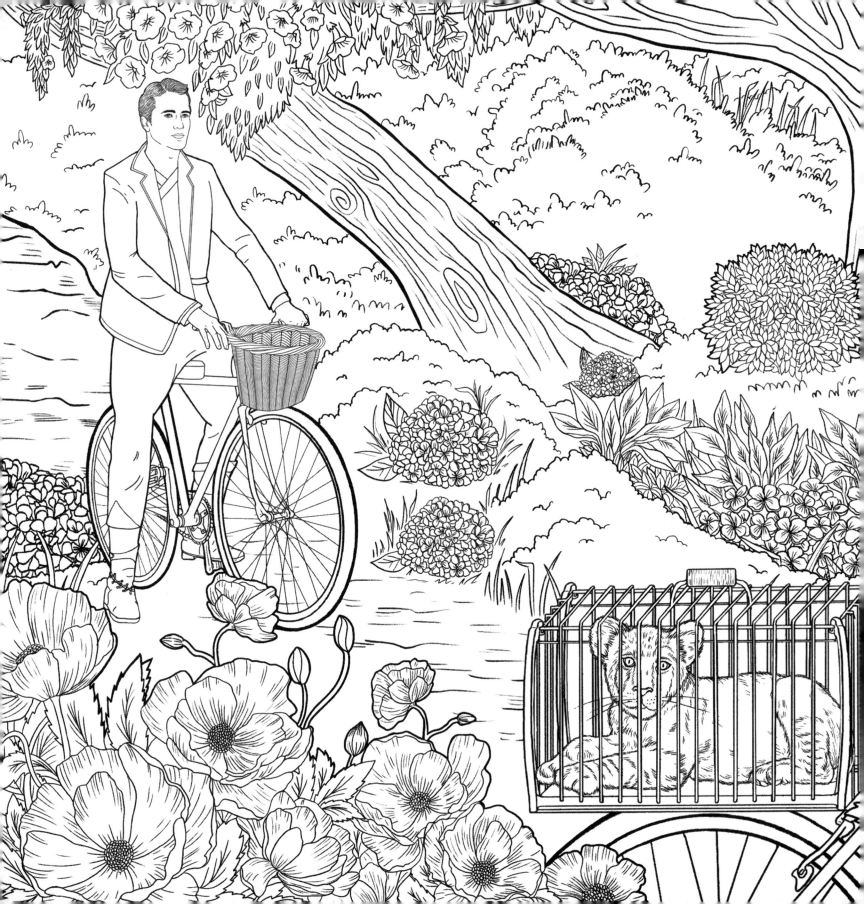

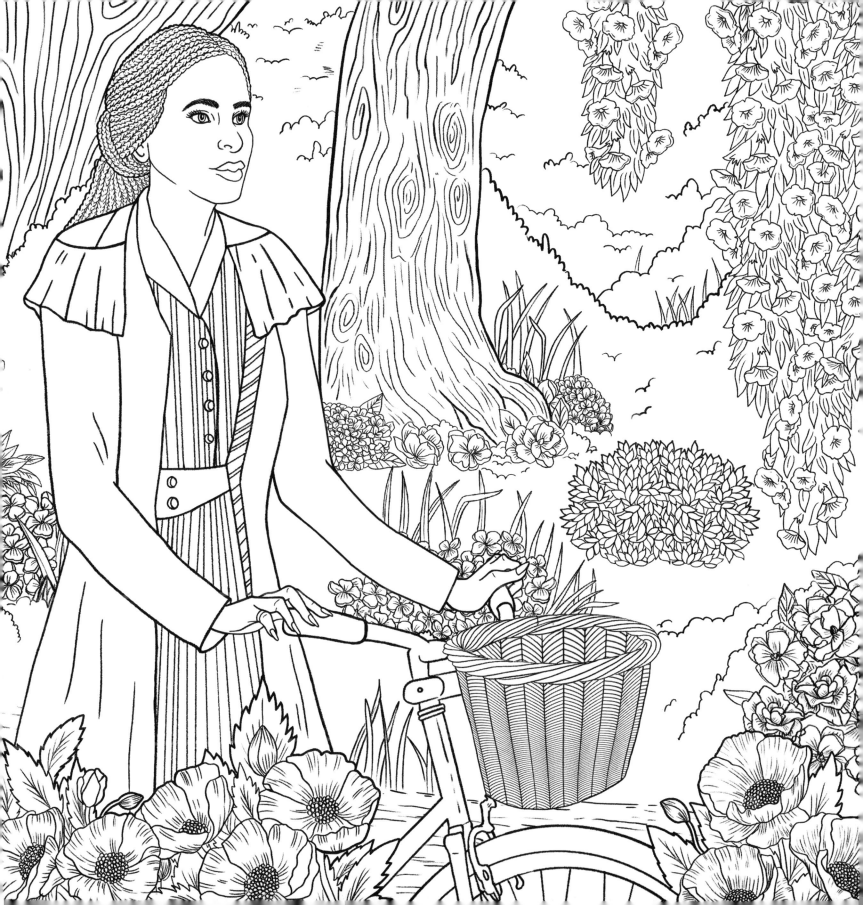

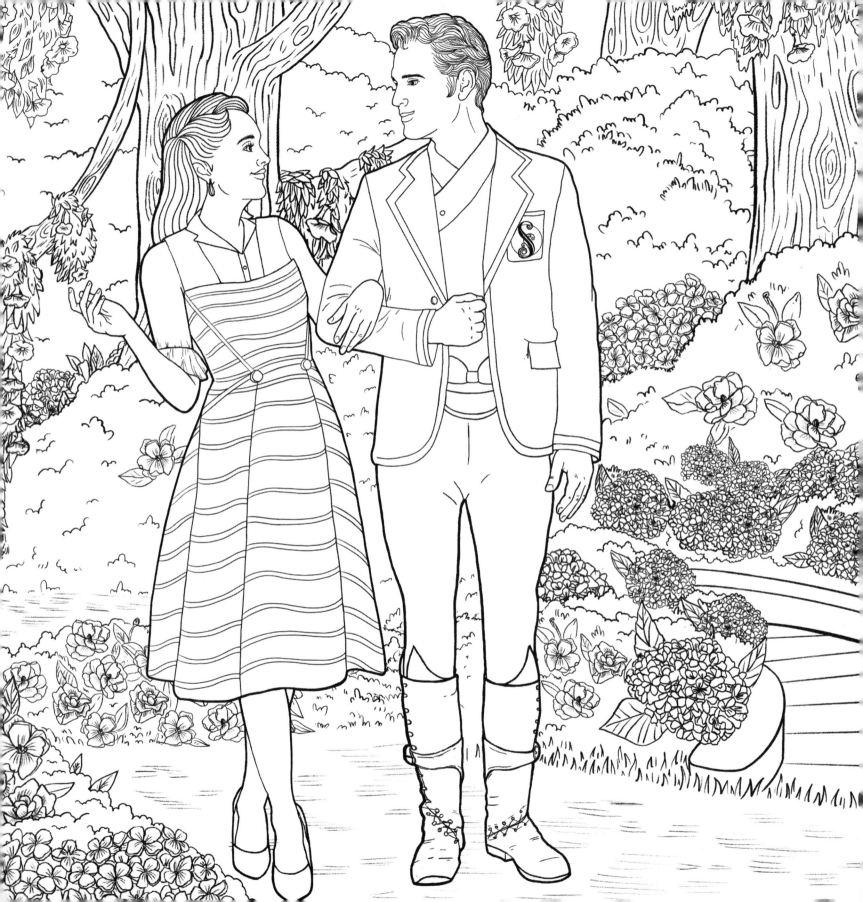

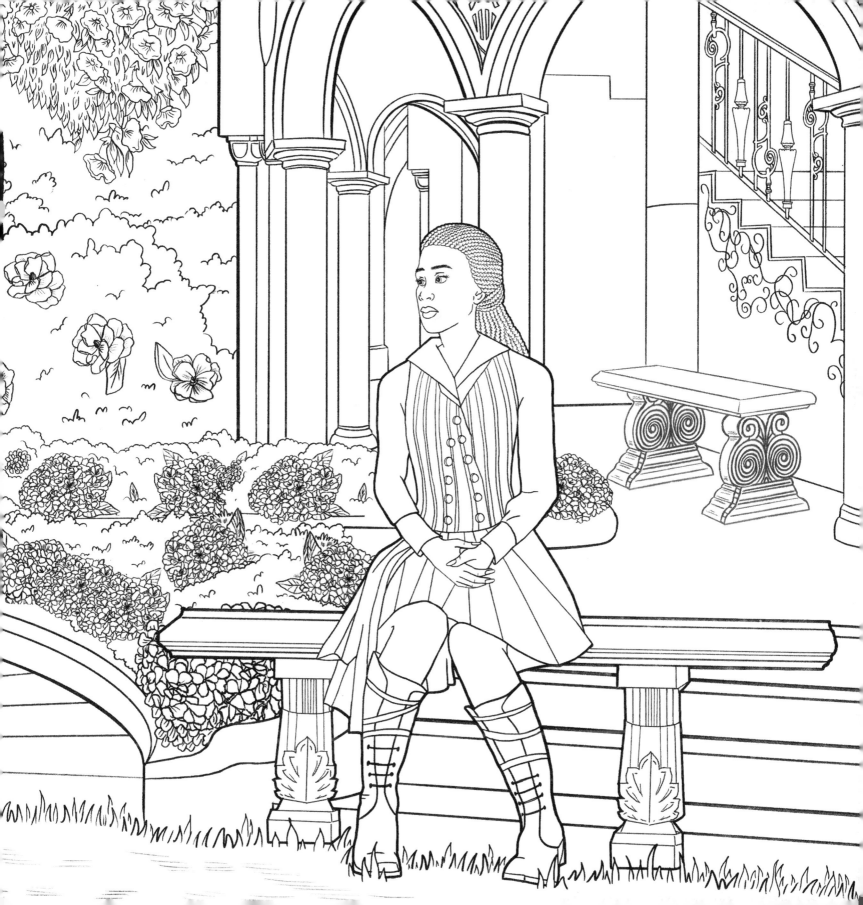

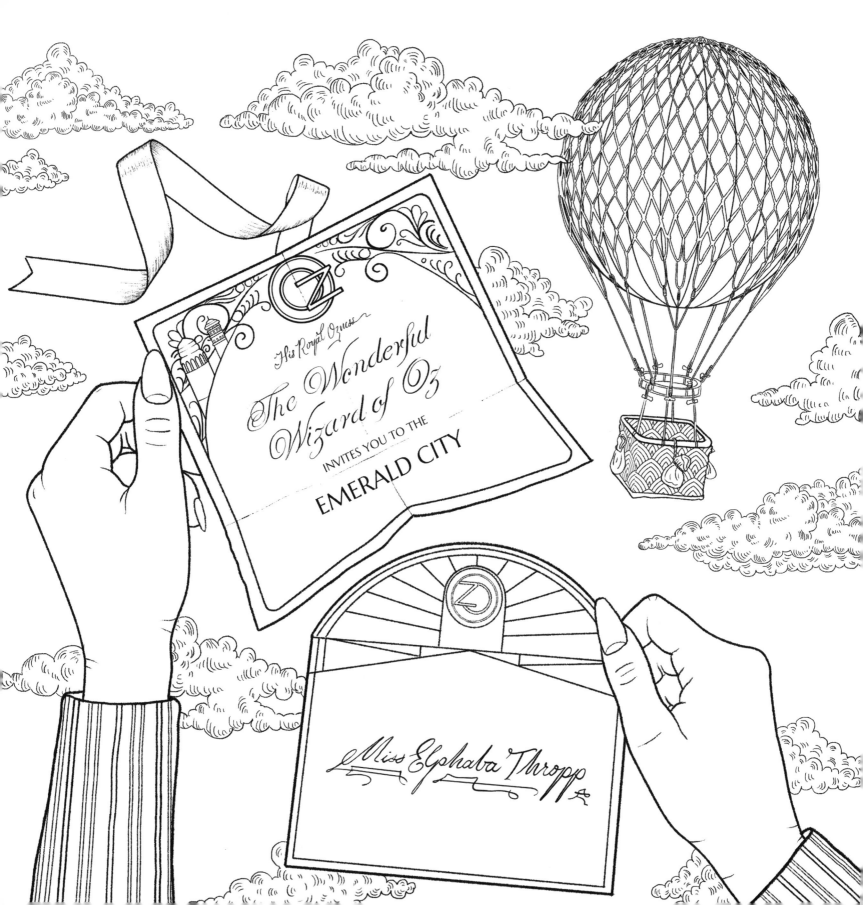

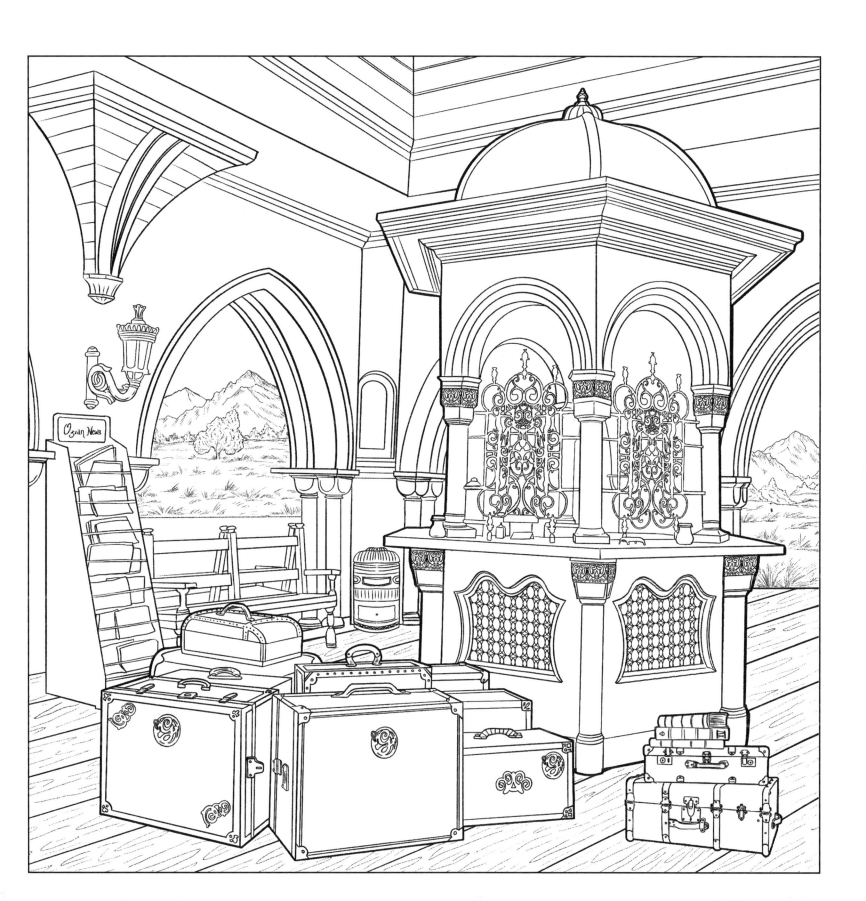

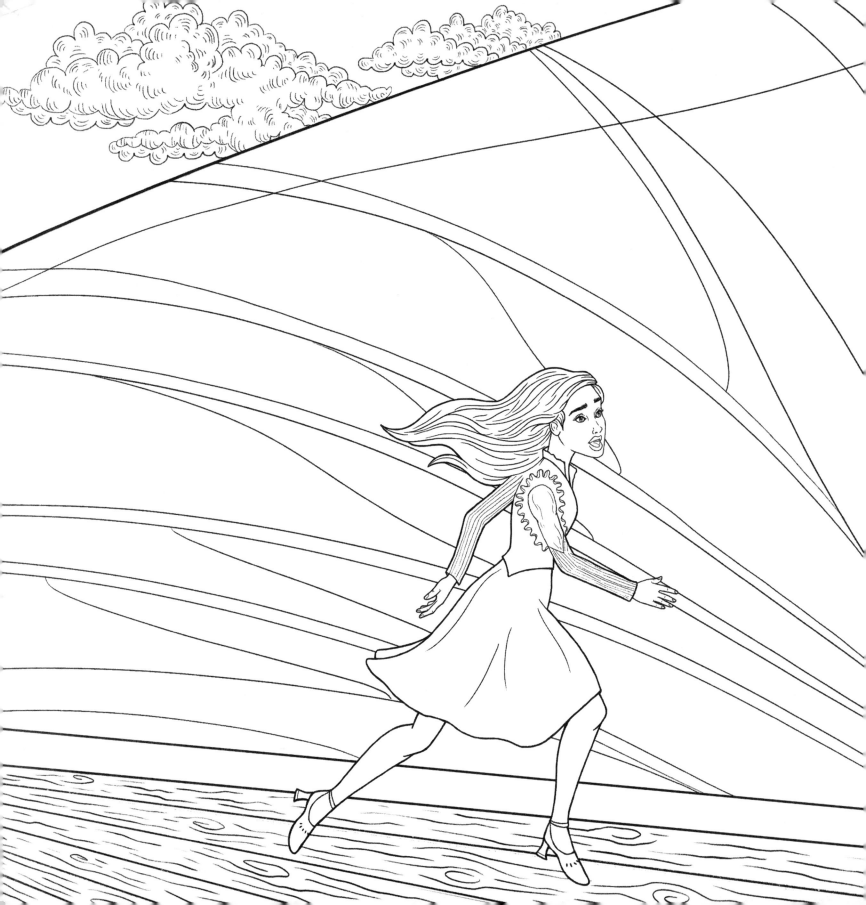

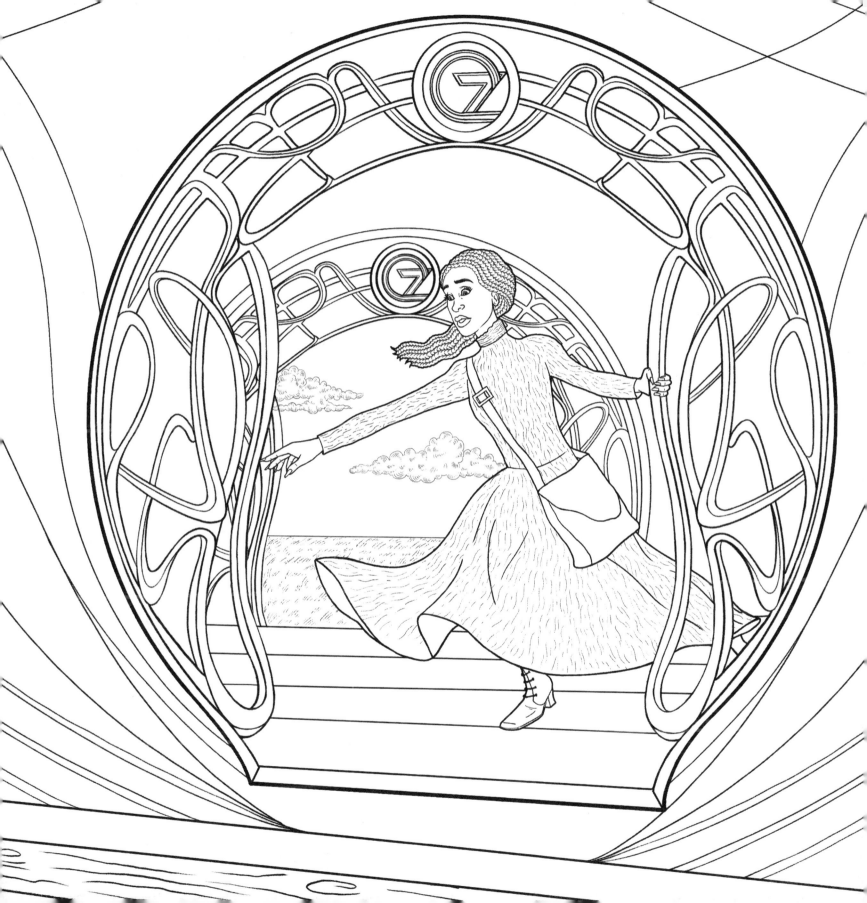

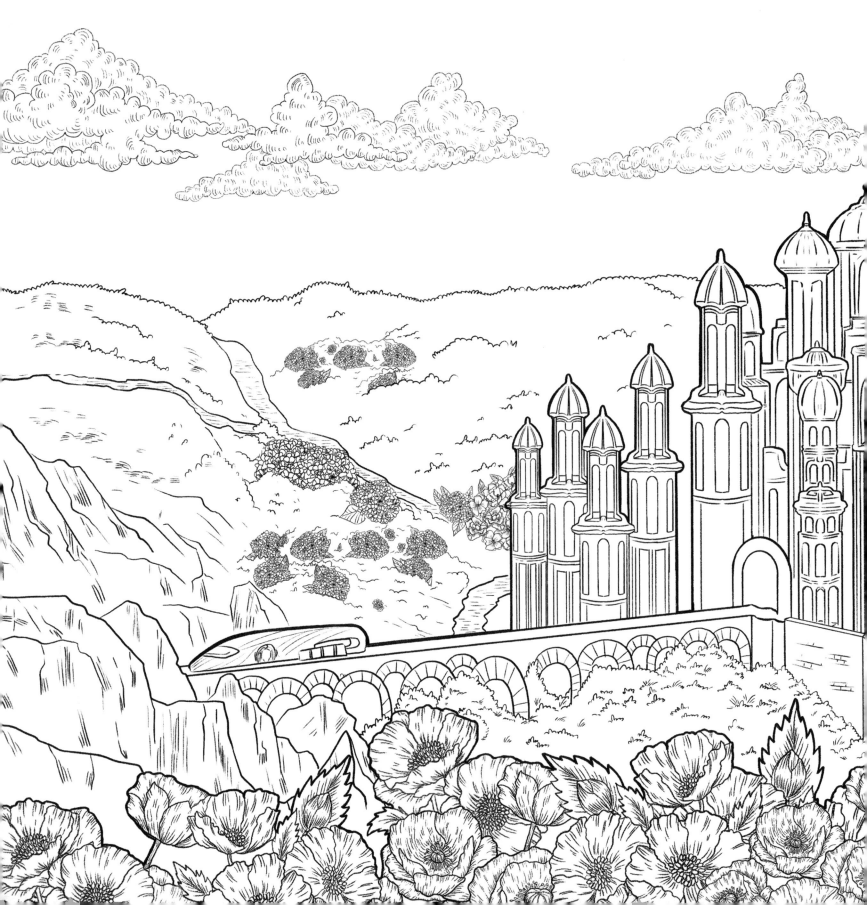

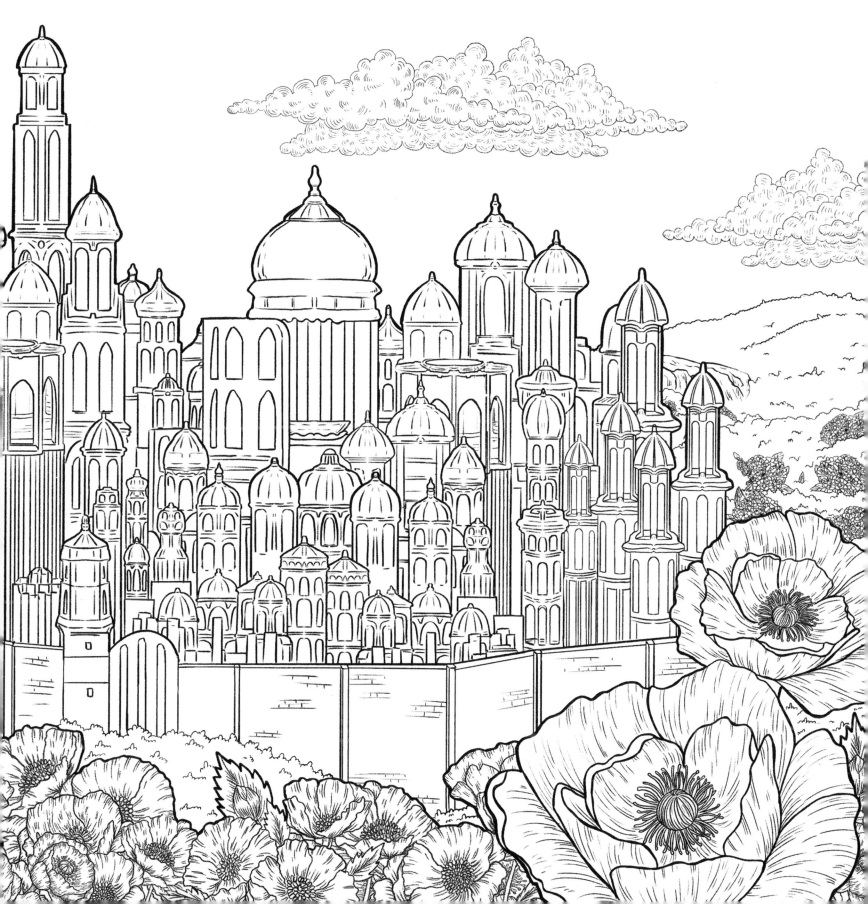

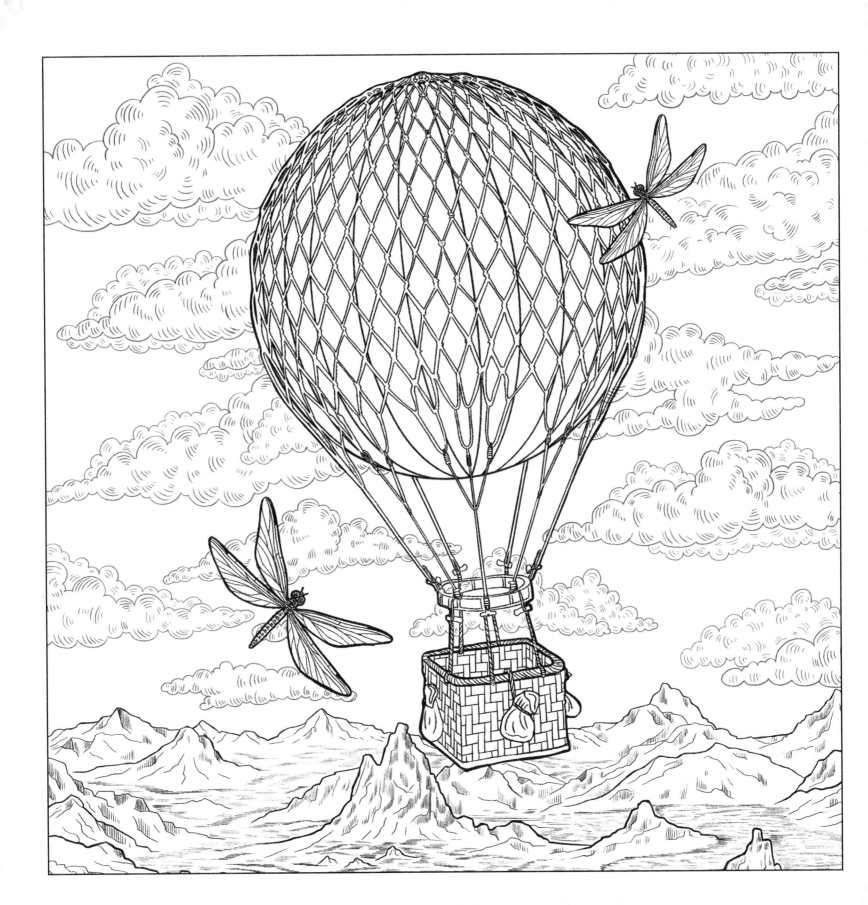

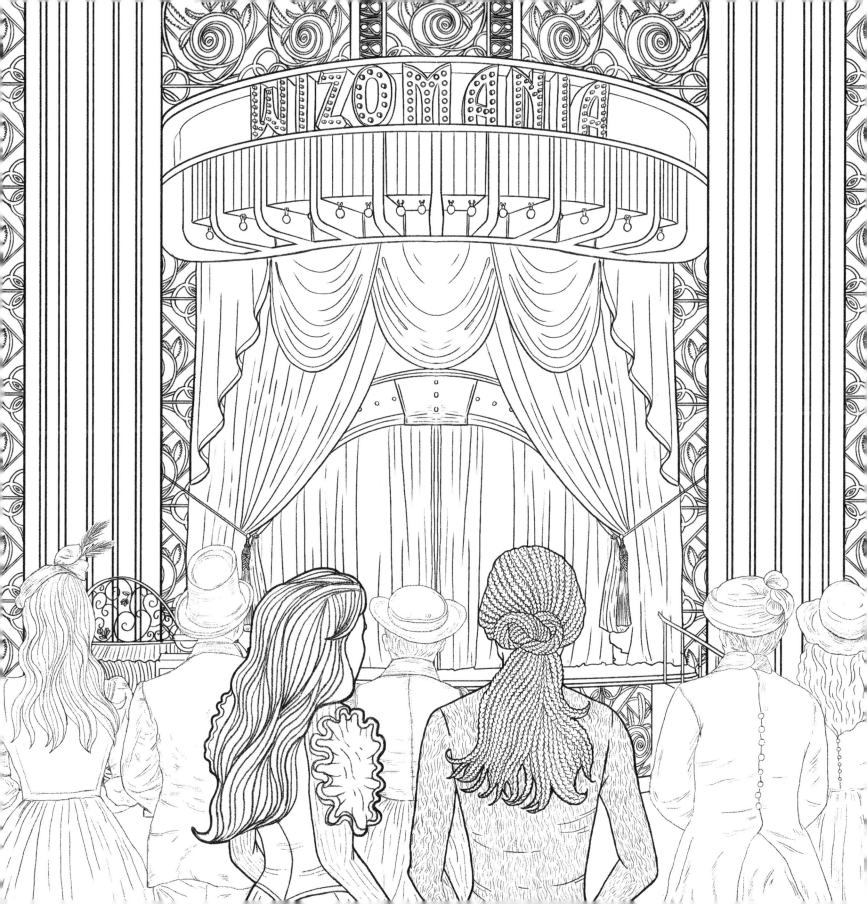

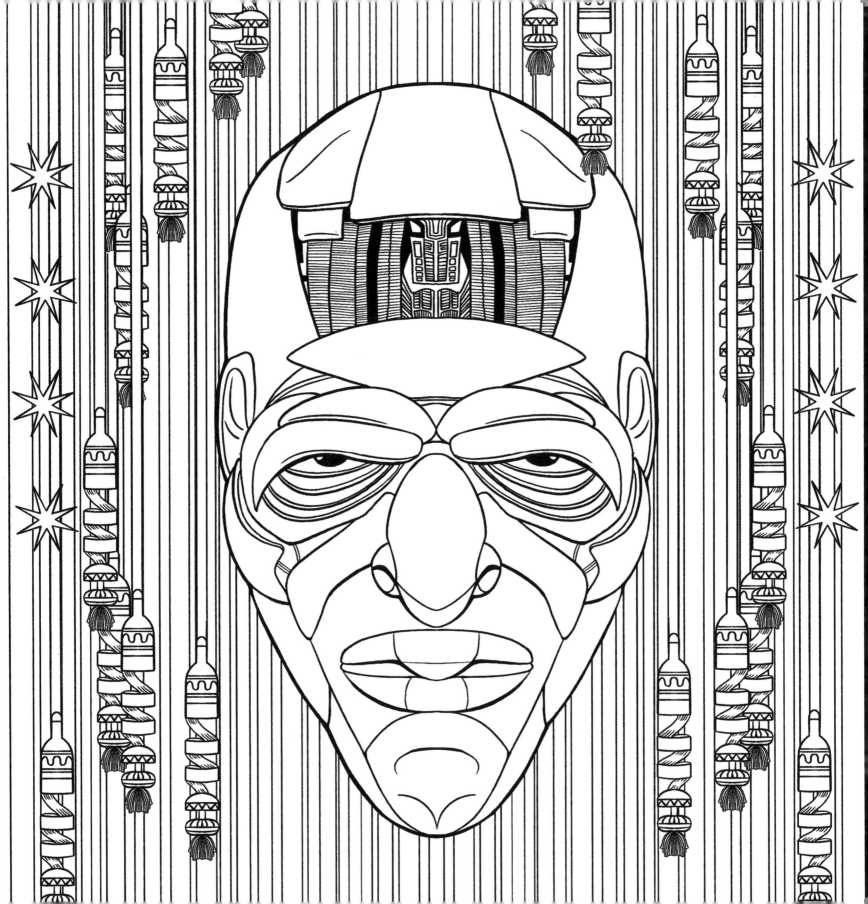

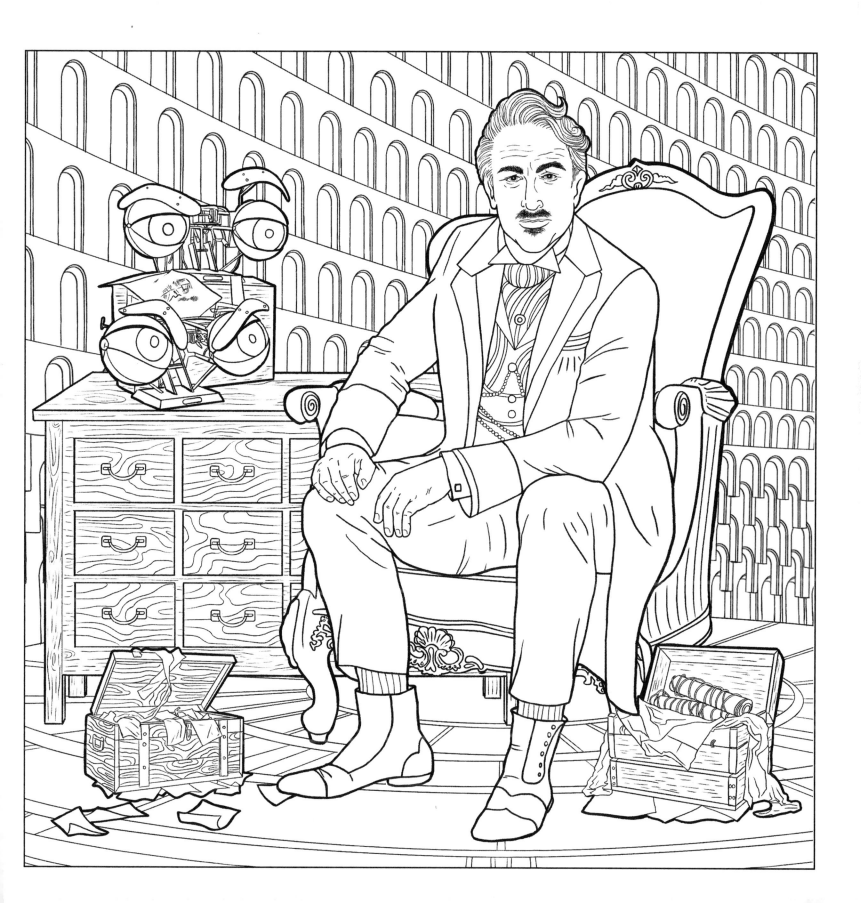

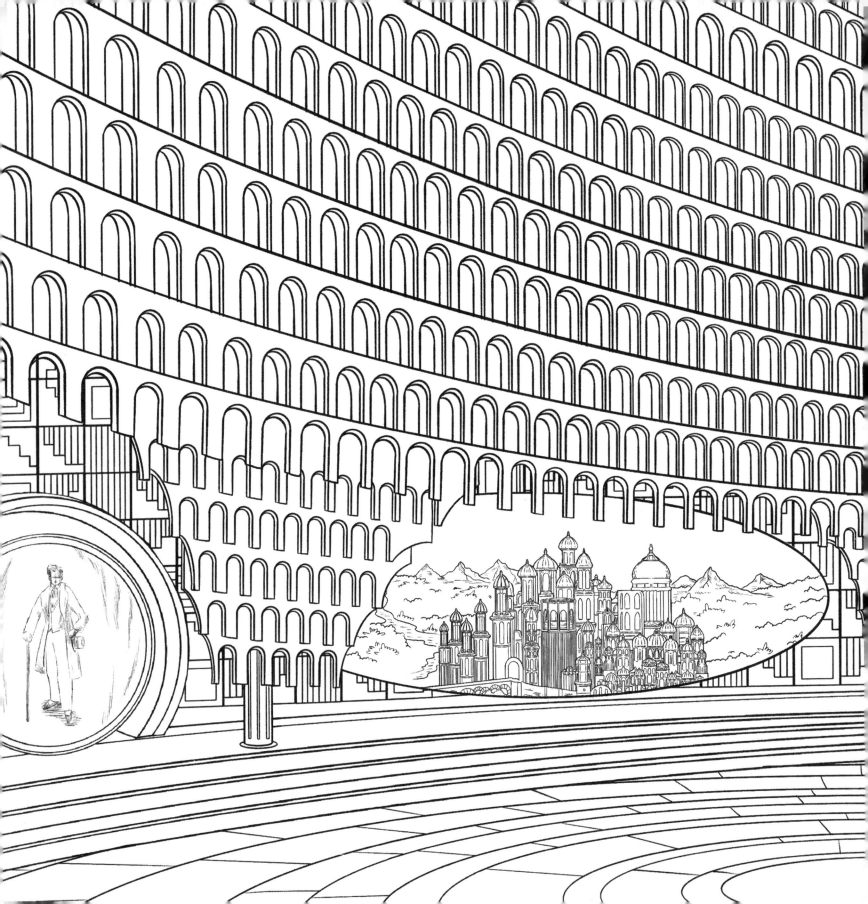

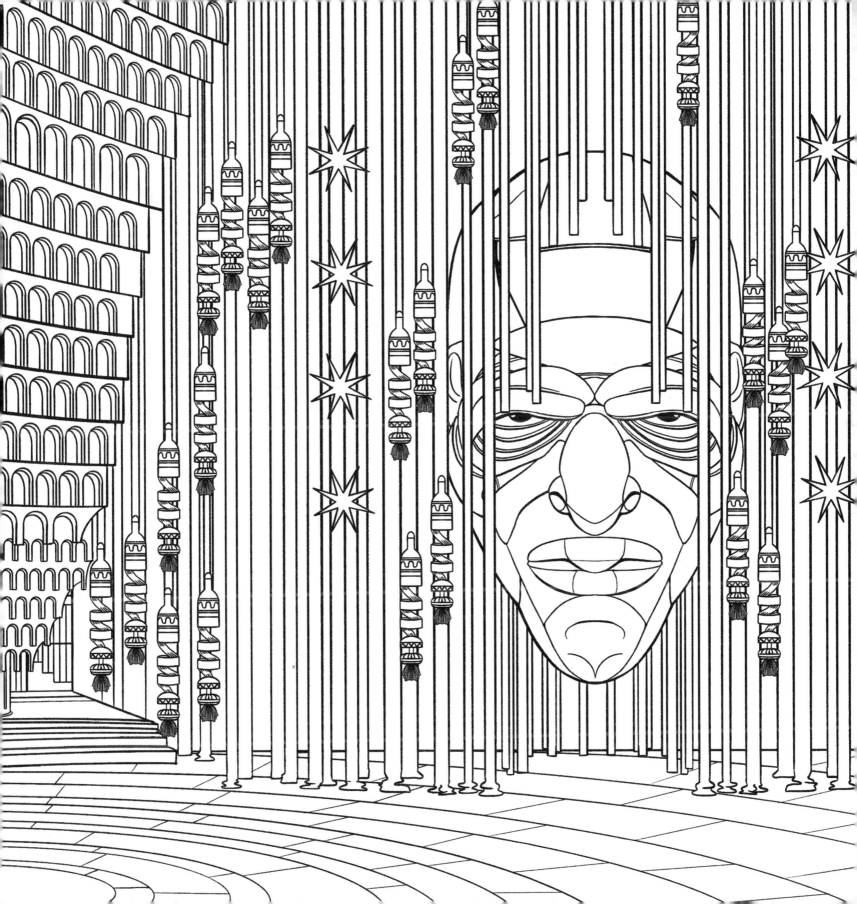

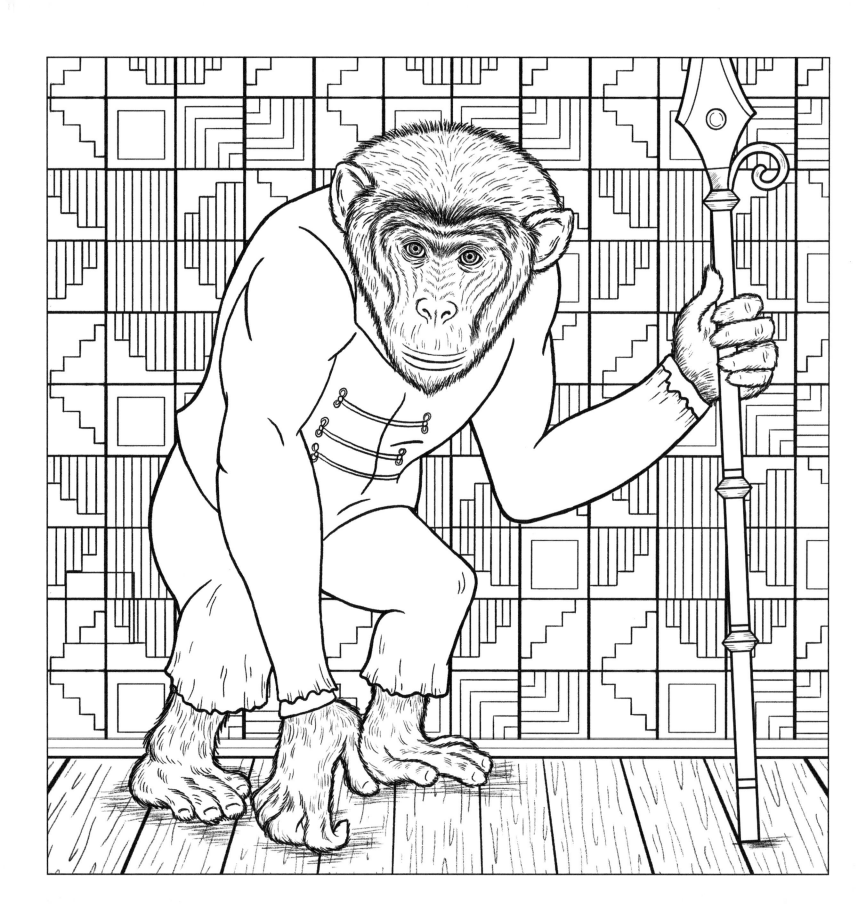

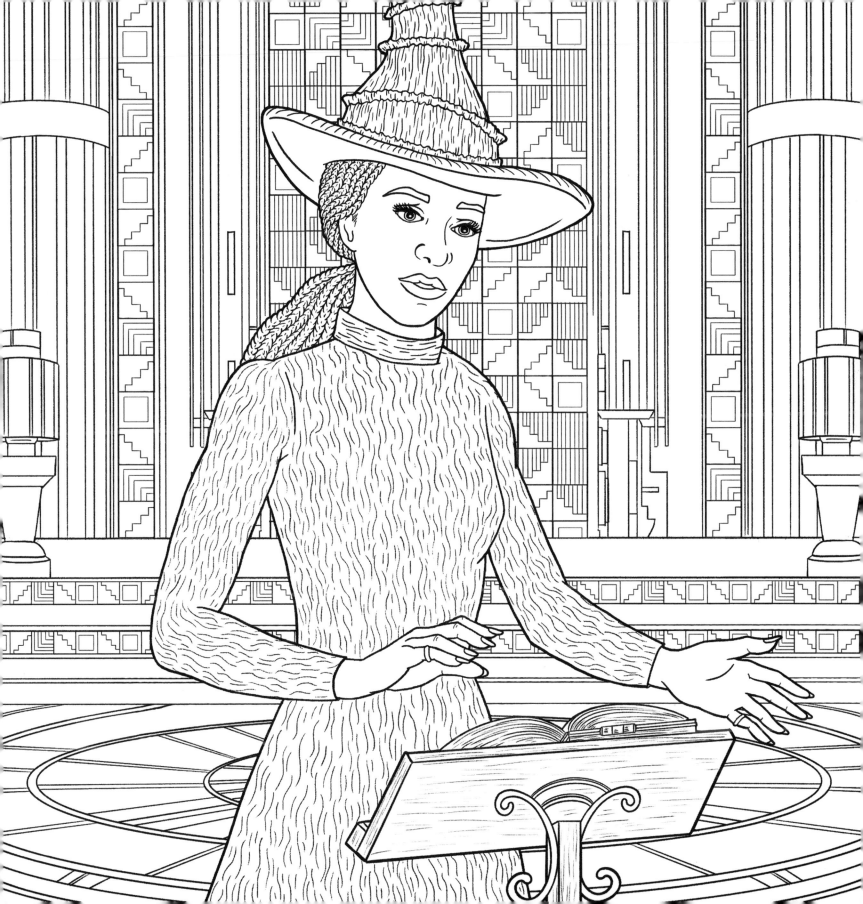

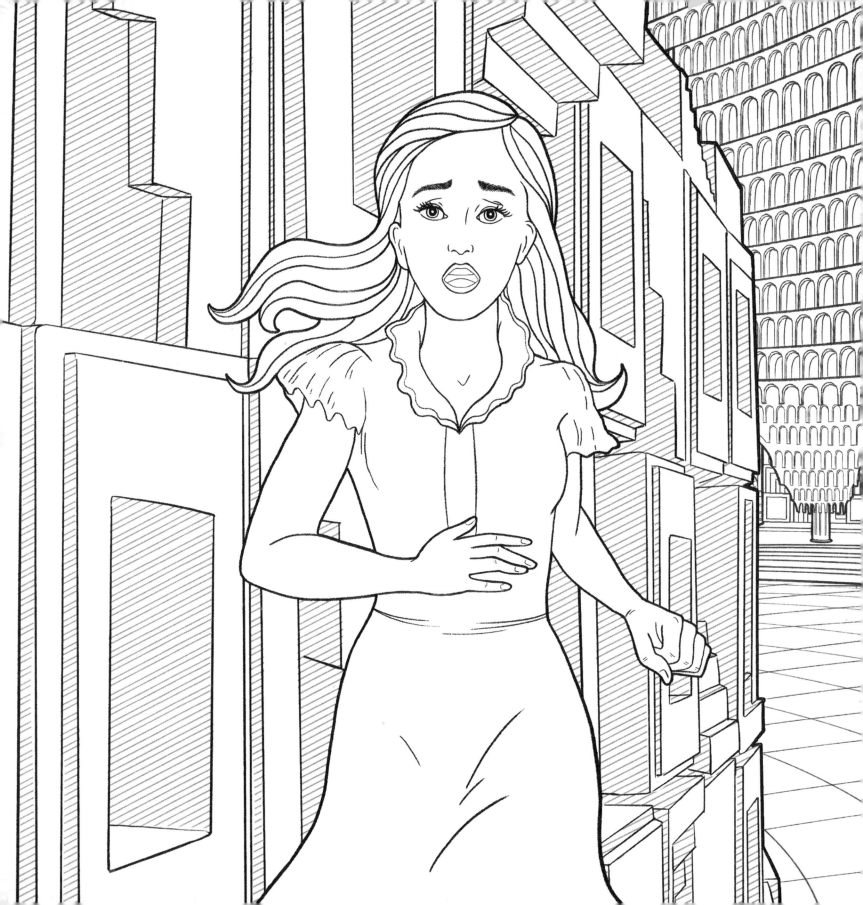

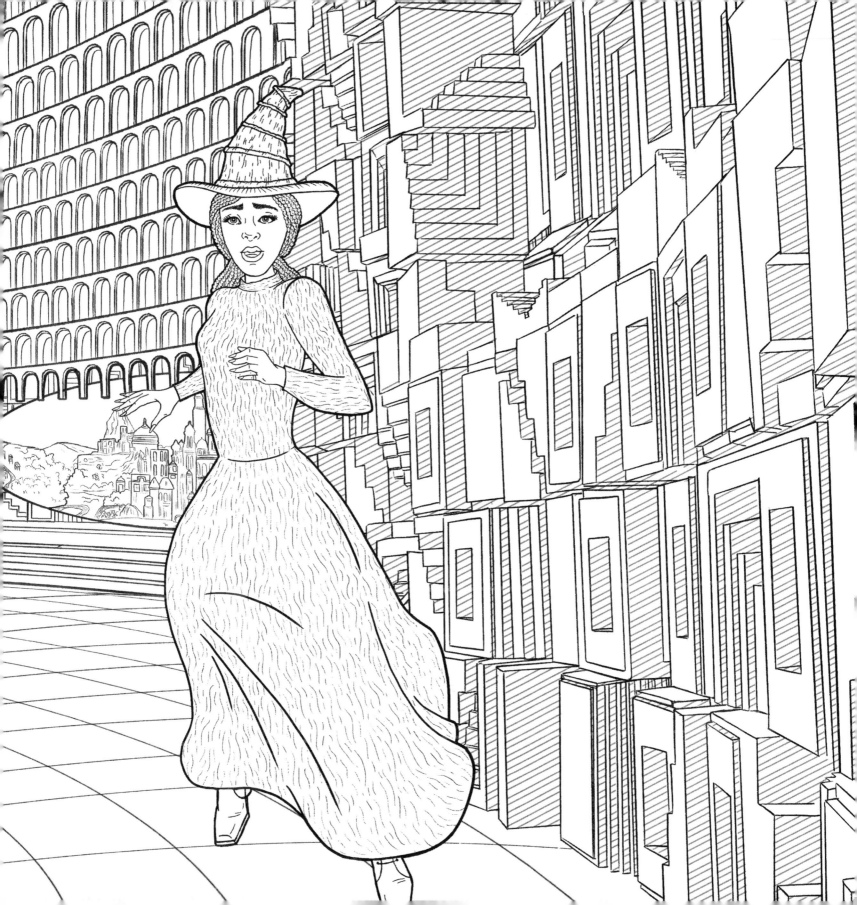

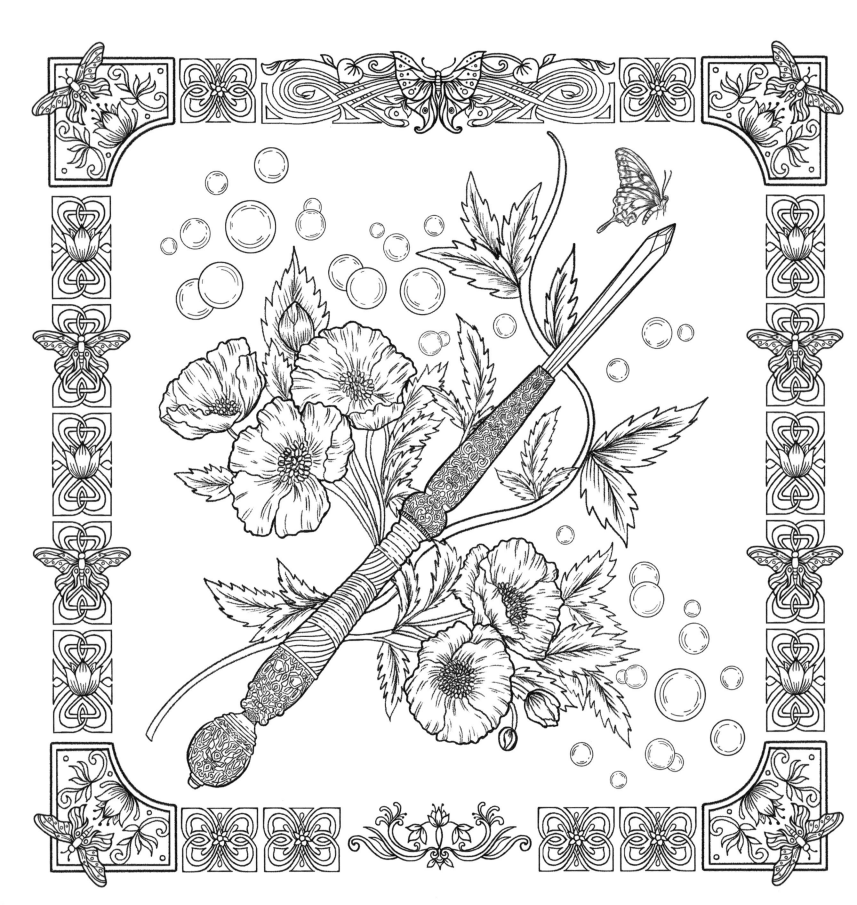

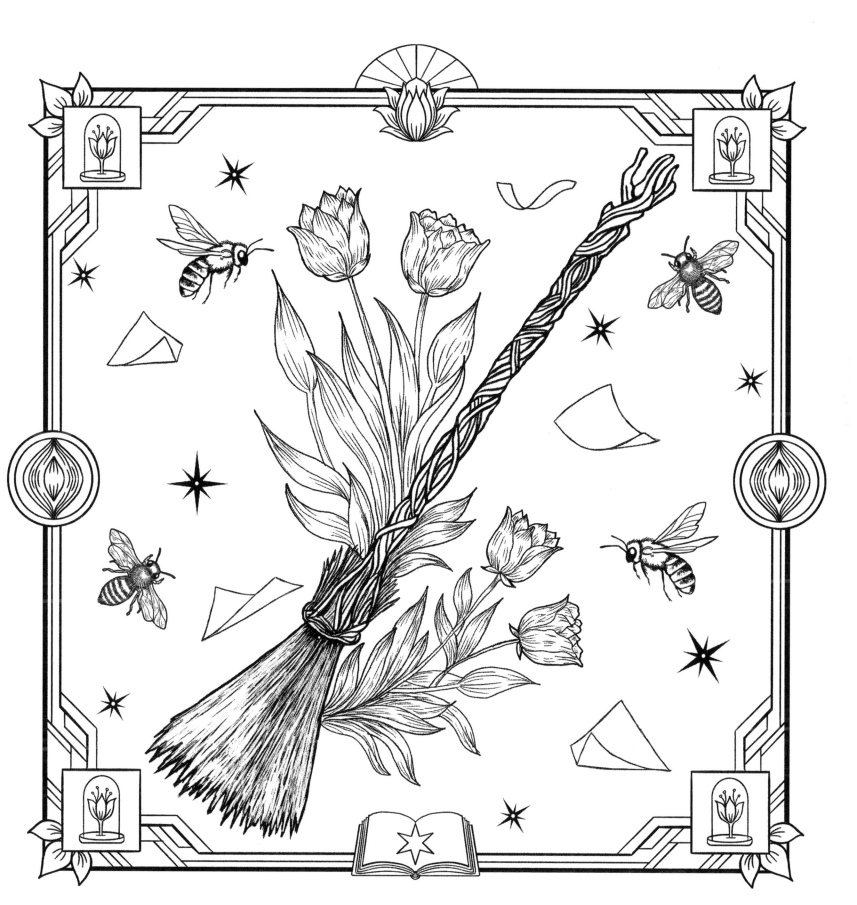

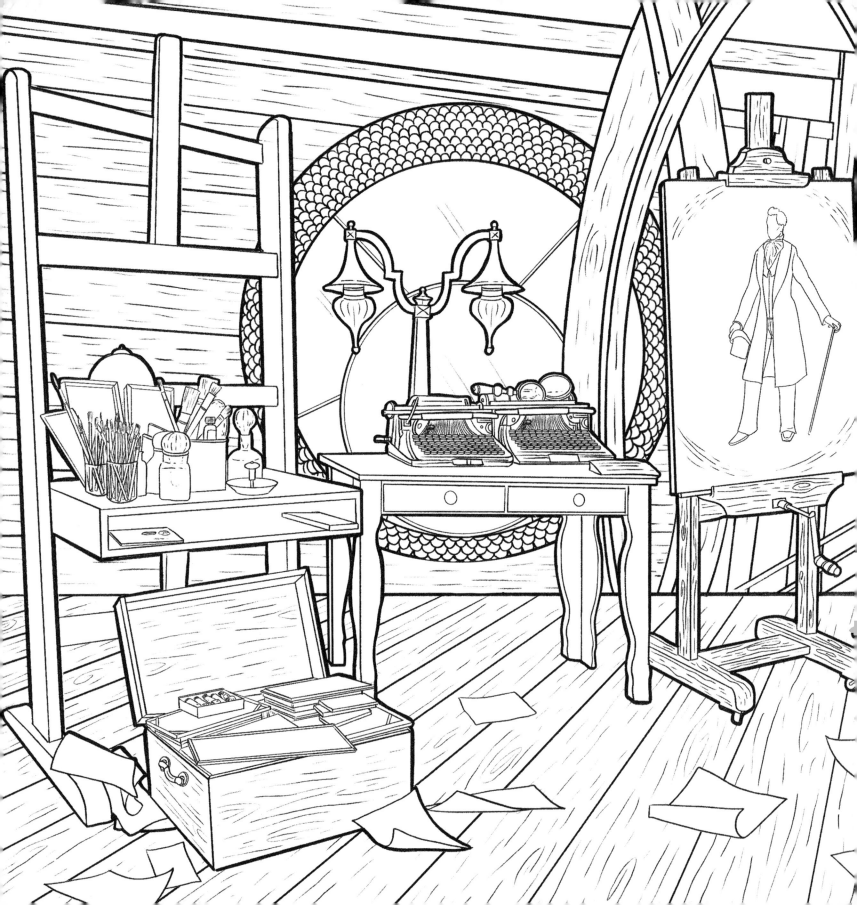

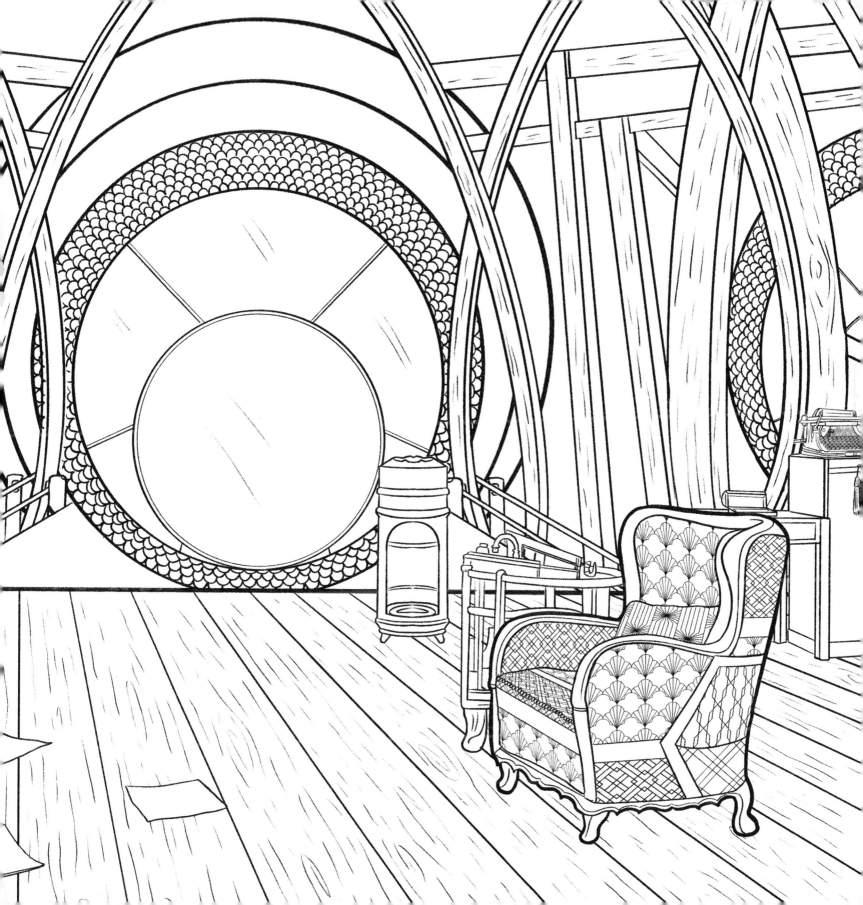

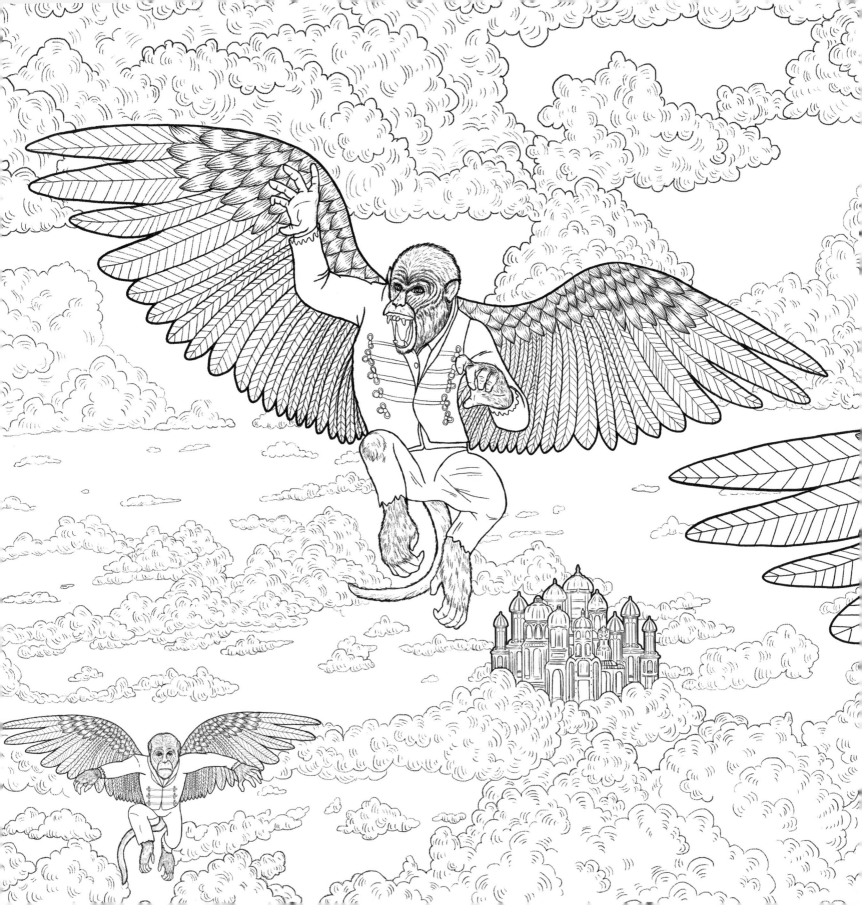

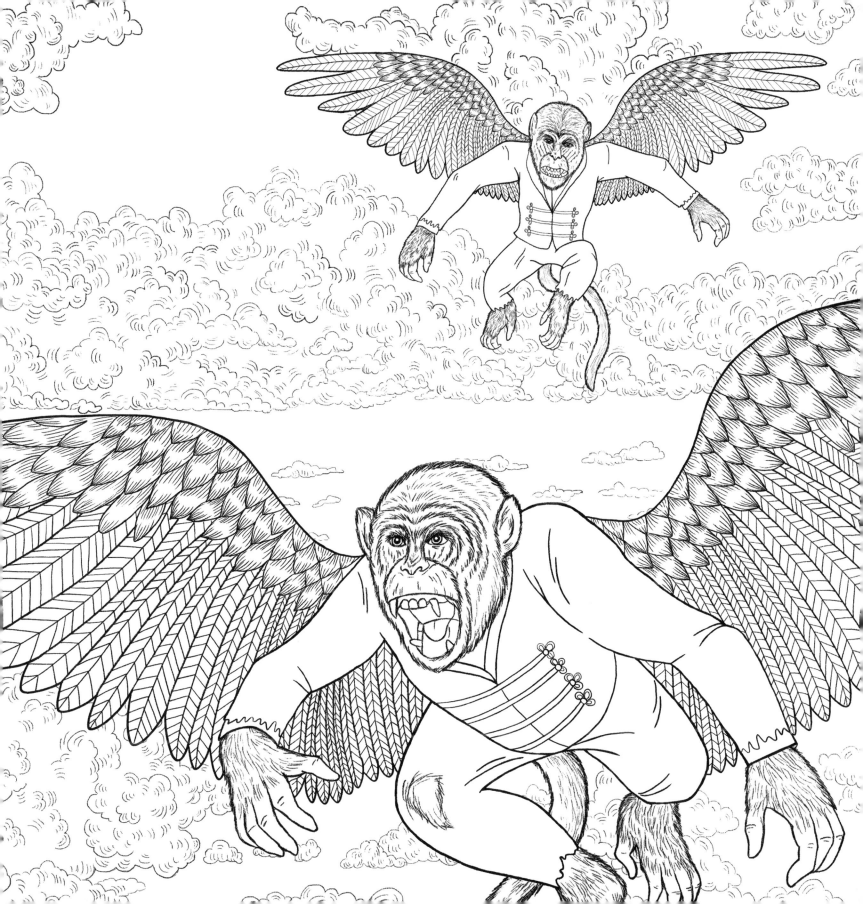

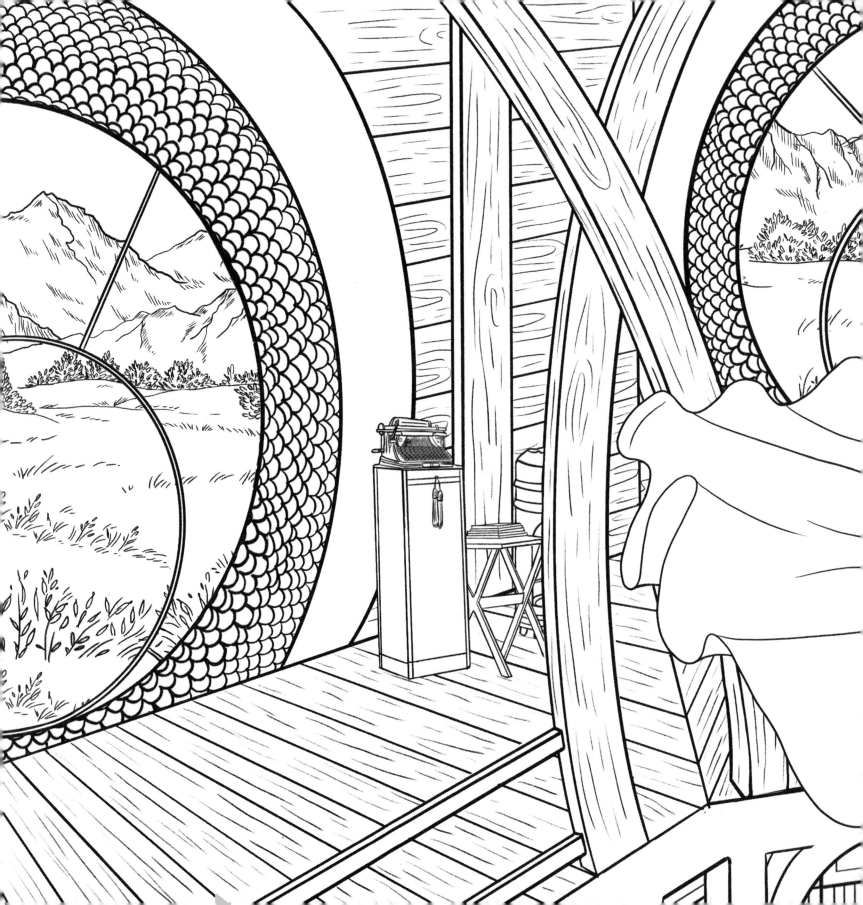

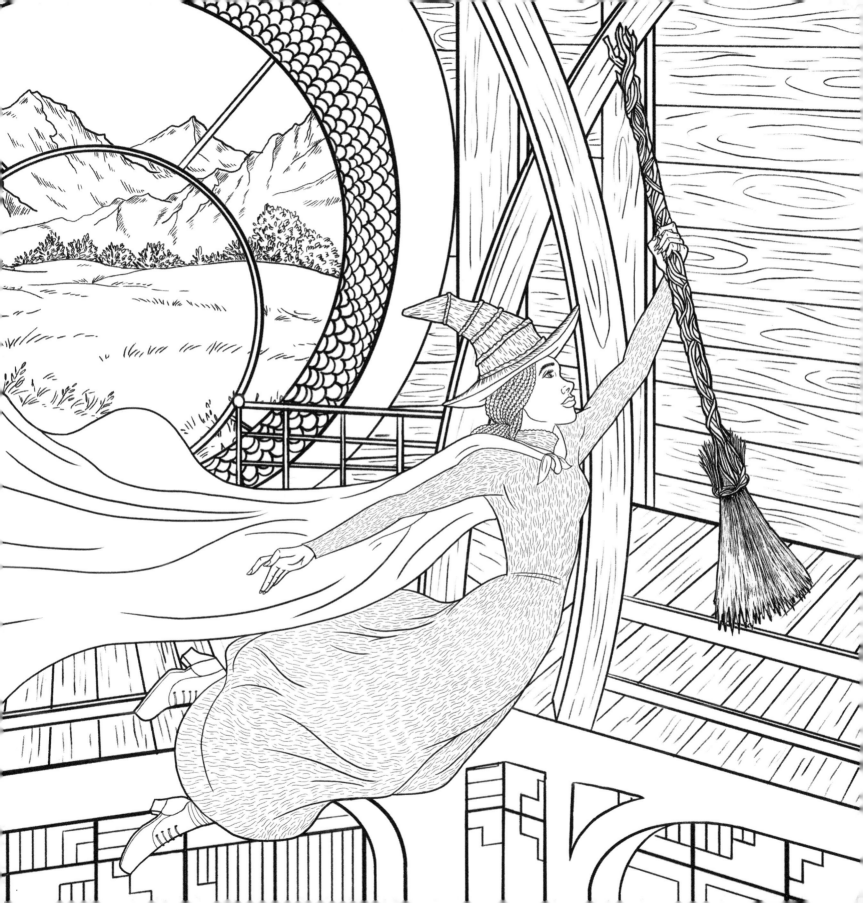

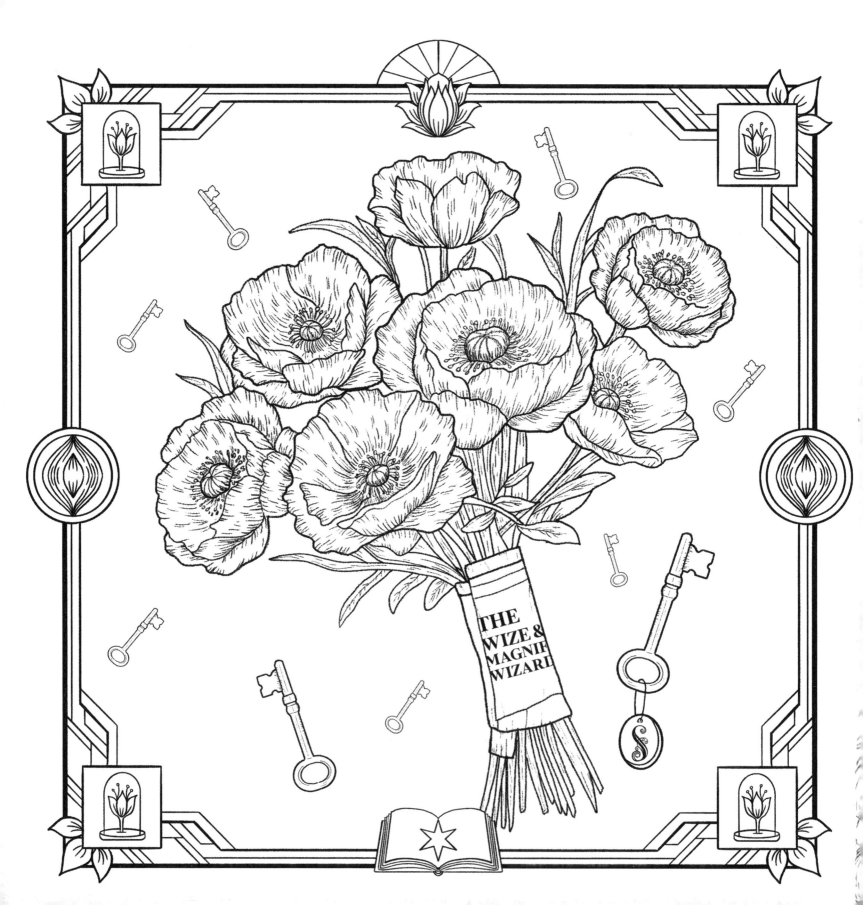

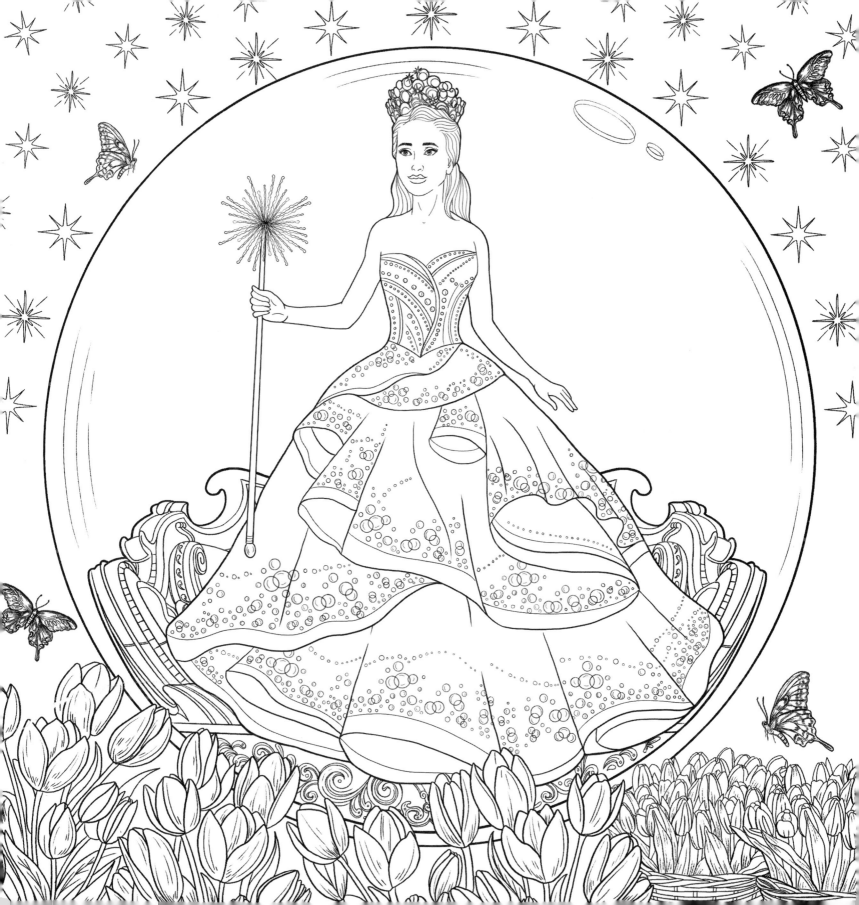

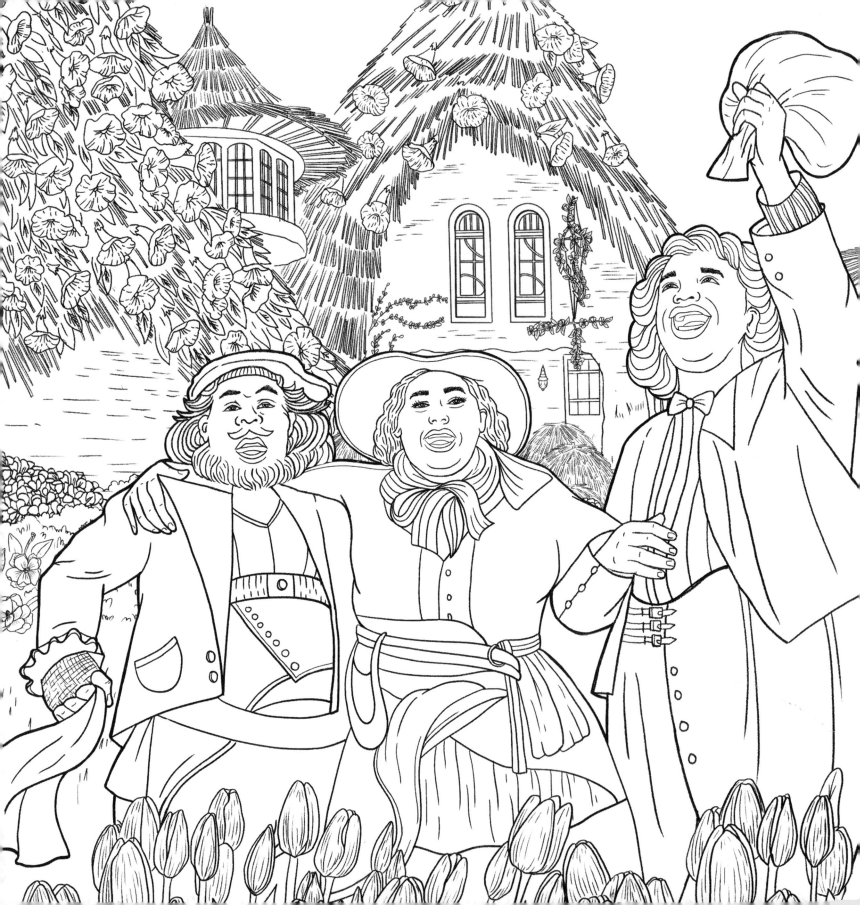

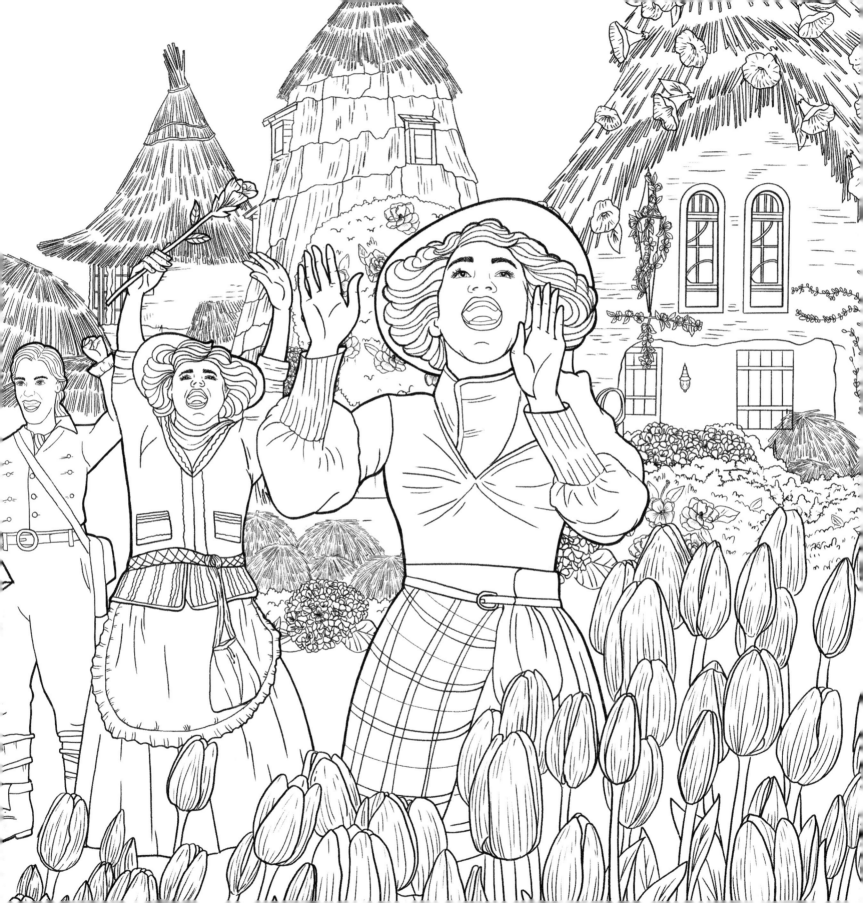

ABOUT THE ILLUSTRATOR

CAROLINA ZAMBRANO is an award-winning illustrator, graphic designer, artist, and Jungian art therapist working in the fields of editorial illustration, advertising illustration, print design, and design applied to objects. Her work addresses topics such as the symbolic world, magic, alchemy, and nature and her creative processes focus on the discovery of personal and collective symbols. She also teaches art and illustration workshops aimed at the development of creative consciousness through symbols from the perspective of Carl Jung's work. She is Colombian and is based in Argentina.